IMAGES
of America
WAYNE FIRE
DEPARTMENT

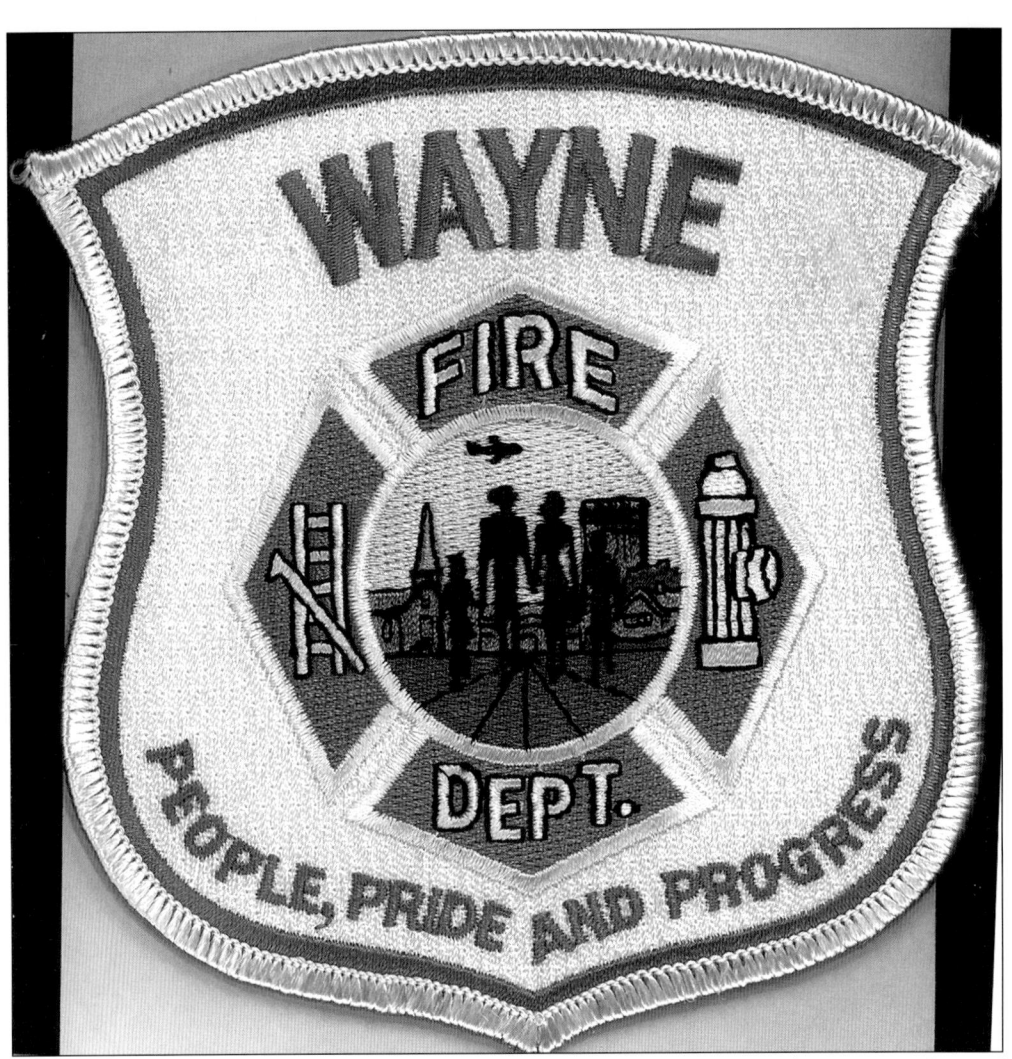

The book is dedicated to the many men, and a couple of women, who have served as Wayne firefighters, past and present. The Wayne Fire Department has protected the community and its residents for 93 years of dedicated service.

IMAGES
of America

WAYNE FIRE DEPARTMENT

Richard L. Story

ARCADIA

Copyright © 2004 by Richard L. Story.
ISBN 0-7385-3278-9

Published by Arcadia Publishing,
an imprint of Tempus Publishing, Inc.
Charleston SC, Chicago, Portsmouth NH,
San Francisco

Printed in Great Britain.

Library of Congress Catalog Card Number: 2004102776

For all general information contact Arcadia Publishing at:
Telephone 843-853-2070
Fax 843-853-0044
E-Mail sales@arcadiapublishing.com
For customer service and orders:
Toll-Free 1-888-313-2665

Visit us on the internet at http://www.arcadiapublishing.com

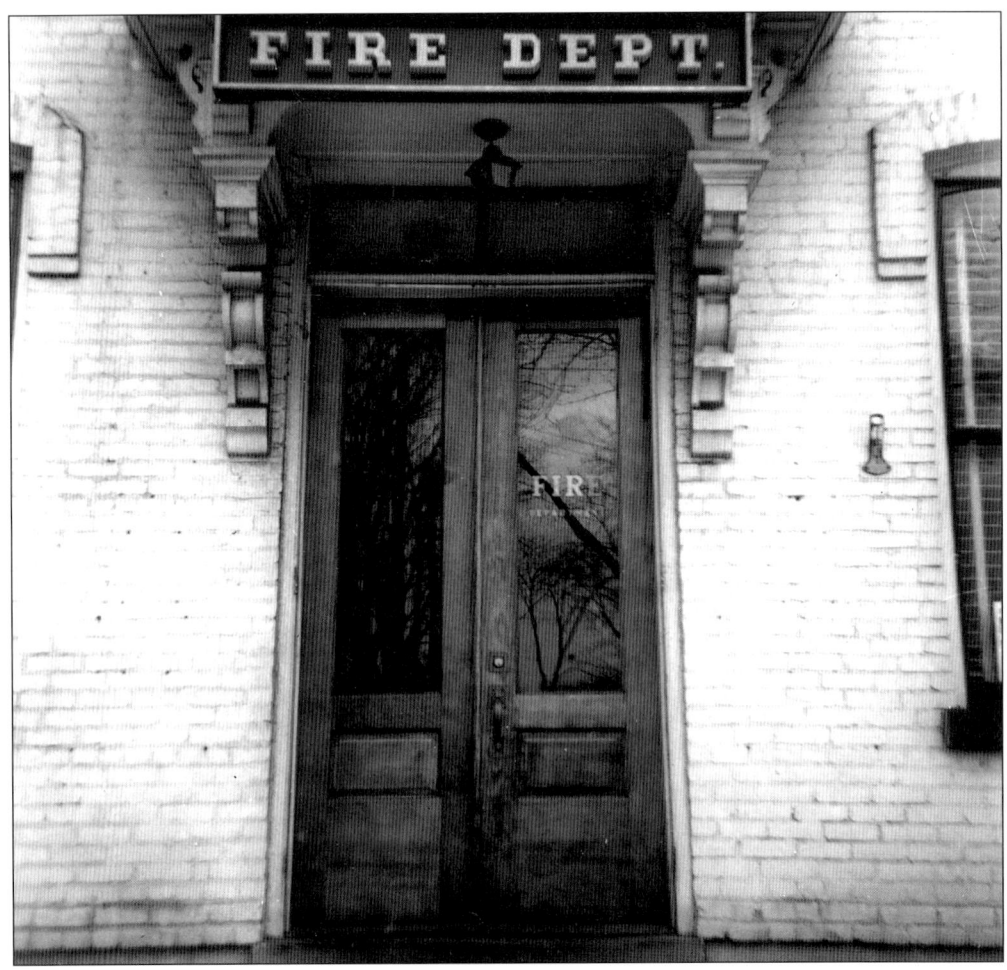

Contents

Acknowledgments		6
Introduction		7
1.	The Beginning	9
2.	1938–1960s	14
3.	1970–2003	57
4.	Michigan Avenue Fire	117
5.	Fire Chiefs	123

Acknowledgments

The process of completing a book of this nature required the assistance of many persons and groups over the years and at the time of the project's completion.

The study of a local fire department goes hand in hand with the study of the community which the fire department serves. The local fire department attends every event in the community's history, from fire emergencies to block parties, and along the way, teaches residents fire safety and fire prevention.

I would like to acknowledge and thank the following persons and groups: Linda, my wife of 32 years, for putting up with me chasing fire trucks; my father, the late Leroy S. Story, for driving me in the car as a boy to follow the fire trucks; my late sister, Nancy Birk; all of the past and present Wayne firefighters; Fire Chief Rob Dahlman, Deputy Fire Chief Mel Moore, retired Fire Chief Ken Warfield, retired Captain Lee Gibelyou, retired Lieutenant George Ferguson, retired Lieutenant Owen McGill, and the late Fire Marshal Neil Prieskorn for their support, understanding, and encouragement; Wayne Firefighters Local 1620 of the International Association of Fire Fighters; my mentor in the fire service, the late Fire Chief Jack O'Callaghan of the Mutual Aid Fire Squad of Michigan, Inc.; the late Westland Fire Department Battalion Chief Joe Benyo, for starting my interest in fire photography; retired Engineer Terry O'Callaghan of the Garden City Fire Department; Mr. and Mrs. James Doletzky; Mr. Jerry Heyer and Wayne Mayor Abdul "Al" Haidous for their assistance; and my son, Richard "Rich" L. Story II, a firefighter-paramedic with the Hazel Park Fire Department, for sharing my interest in the fire service. Rich has two daughters, Janie, age four, and Lillian, a newborn. Who knows if there will be a Story in the future of the fire service?

INTRODUCTION

The present-day area of Wayne was first settled February 27, 1824. By the time Wayne was incorporated as a village on April 12, 1869, with 800 residents, fires were common and destructive.

In 1880 the Village of Wayne purchased one 40-gallon Babcock Fire Extinguisher, 36 pails, and 13 ladders at the cost of $96.13. In April of 1893, a fire struck the bank downtown, and the fire was too large for the Wayne residents' bucket brigade. A telegraph was sent to the Detroit Fire Company for assistance, and Detroit sent a steam fire engine and hose cart via the New York Central Railroad. It took an hour and a half to arrive in Wayne. The building burned to the ground, but the rest of the village was saved. Detroit sent Wayne a bill in the amount of $100 for the service.

In late 1893, the Village Council purchased a Ramsey Hand Pump Fire Engine and two hose carts for $250. The engine was stored at the Proudy and Glass Carriage Factory on Sophia Street, and the factory workers would pull the engine to fires when needed.

In 1911, the Village Council formed a 12-man volunteer Wayne Fire Department with Charles Goudy as Fire Chief. In 1914, domestic water mains complete with fire hydrants were installed in the village. In 1917, a Ford Model-T truck was purchased and used as a hose truck for the fire department.

In the year 1928, the Village Council approved hiring three full-time firemen. The men were Charles Goudy, Dan Doletzky, and Hank Goudy. The men were paid $1 per day and worked ten days at a time with one day off; they received $4 for every fire they responded to. A 1928 American La France 1,000-gallon-per-minute pumper was purchased at a cost of $12,000. It was the first of its kind in western Wayne County.

On April 1, 1942, the Village of Wayne and the Township of Nankin signed an agreement forming the Wayne-Nankin Fire Department. For the first time in its history, Nankin Township now had a fire department. Nankin Township purchased its first fire truck—a 1938 Ford American—and purchased its second fire truck in 1947. In 1950, Nankin Township built its first fire station on Ford Road. It was known as Wayne-Nankin Fire Department Station 2.

In 1952, the Village of Wayne built a new fire station at 3300 Wayne Road which was the headquarters of the Wayne-Nankin Fire Department. This was followed by the 1953 purchase of

two new fire trucks. One was a ladder truck, the first such rig in the western Wayne County area.

After World War II, Wayne-Nankin Fire Department took over the fire station in Norwayne Housing Project, which was the home of the Norwayne Fire Department. This became the third fire station belonging to the Wayne-Nankin Fire Department. Nankin Township purchased two new pumpers in the late 1950s.

On July 5, 1960, the Village of Wayne became the City of Wayne, and on December 31, 1962, the Wayne-Nankin Fire Department was dissolved. The City of Wayne Fire Department once again only protected the area of Wayne. The City of Wayne purchased a new pumper in 1962 and hired 10 full-time firefighters.

In 1966, the City of Wayne took over the ambulance service in the city and firefighters were trained in Advanced First Aid and Emergency Care. Fire Chief Hank Goudy, a 44-year employee of the Wayne Fire Department, retired on July 1, 1971. That same summer, a house exploded on the city's southwest side and injured four firefighters and one police officer.

On January 26, 1975, a new pumper arrived at the Wayne Fire Department, followed in 1978 by a new ladder truck. In 1975 the Wayne Department of Public Safety was founded, with a public safety director overseeing the operation of the fire and police departments. The Fire Department then became known as the Wayne Fire Division. Dispatching of the fire apparatus was taken over by civilian dispatchers.

On April 13, 1985, the largest fire in the history of the Wayne Fire Division took place in a block of buildings in the downtown area, causing a $1 million loss. The department received a new pumper in 1987.

In 1991, the Public Safety Department was dissolved and the fire department was once again called the Wayne Fire Department. In 1999, the Wayne Fire Department started to provide Advanced Life Support to the residents of Wayne.

In the year 2000, as the fire station on Wayne Road was torn down to make way for a new fire station, a new temporary fire station was built to house the Wayne Fire Department. Ground was broken in June of 2002 for the new fire station, and firefighters were in their new home September 23, 2003.

The Wayne Fire Department continues to serve the residents of Wayne with a first-class operation and a group of dedicated firefighters.

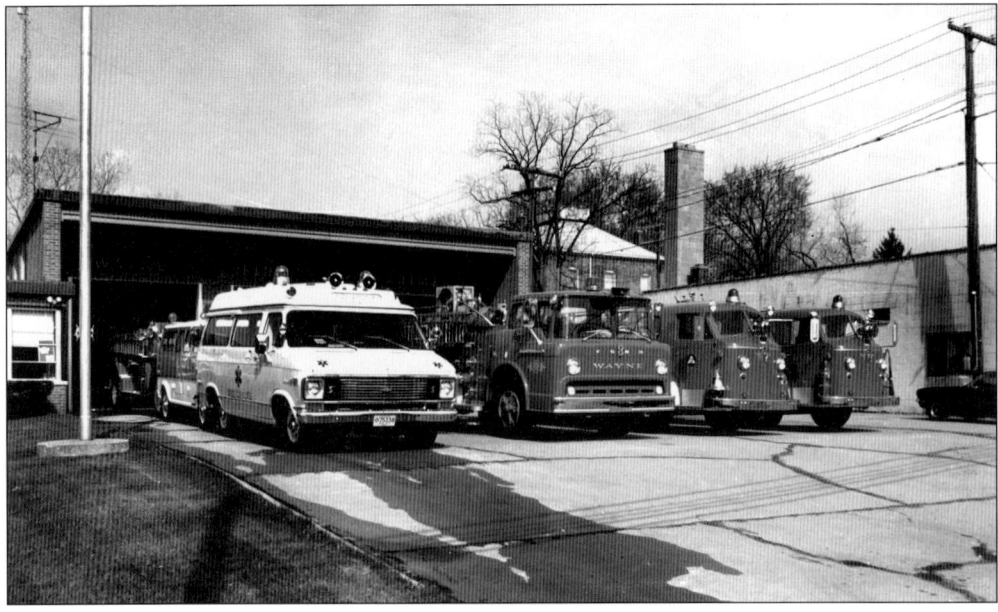

One
THE BEGINNING

The Village of Wayne purchased its first fire fighting equipment in 1880 at a cost of $96.13. It was not until 1893 that additional fire fighting equipment was purchased. A Ramsey Hand Pump Engine, two hose carts, and fire hose were purchased at a cost of $250. The residents of the town had to form bucket brigades during a fire and use what equipment that was at hand.

In the year 1911, the Village Council formed a volunteer Wayne Fire Department with 12 volunteer firemen, who were under the direction of Fire Chief Charles Goudy. In 1914, a domestic water supply system was installed in the town, complete with fire hydrants. It was great improvement in fire fighting.

The first motorized vehicle was purchased in 1917. It was a Ford Model-T used as a hose and chemical truck. In 1928, the first fire truck was purchased. It was 1928 American La France 1,000-gallon-per-minute pumper costing $12,000—the first of its kind in western Wayne County.

Fire Chief Charles Goudy was made a full-time fire chief, and two more men, Dan Doletzky and Hank Goudy, were hired as full-time firemen. The men were assisted by the volunteer fireman.

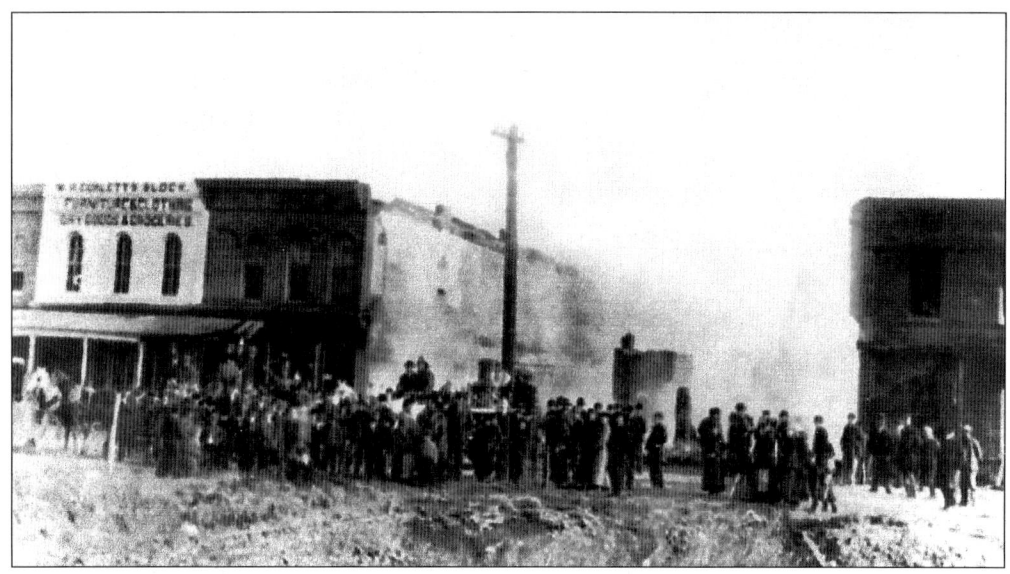

Fire struck the Wayne Savings Bank on April 9, 1893. Residents with the bucket brigade could not control the fire. A telegram requesting help was sent to the Detroit Fire Company. Engine No. 5 and hose cart were sent from Detroit via the New York Central Railroad, taking an hour and a half to arrive in Wayne. The steam engine pumped water from the Rouge River, and the building was lost but the town was saved. Detroit sent Wayne a bill for $100 for their services. In this photo, Wayne residents pose with members of the Detroit Fire Company.

In 1893, the Village of Wayne purchased a Ramsey Hand Pump fire engine, two hose carts, and fire hose at a cost of $250. The Ramsey Hand Pump fire engine is parked next to the Village Hall in this photo on the left.

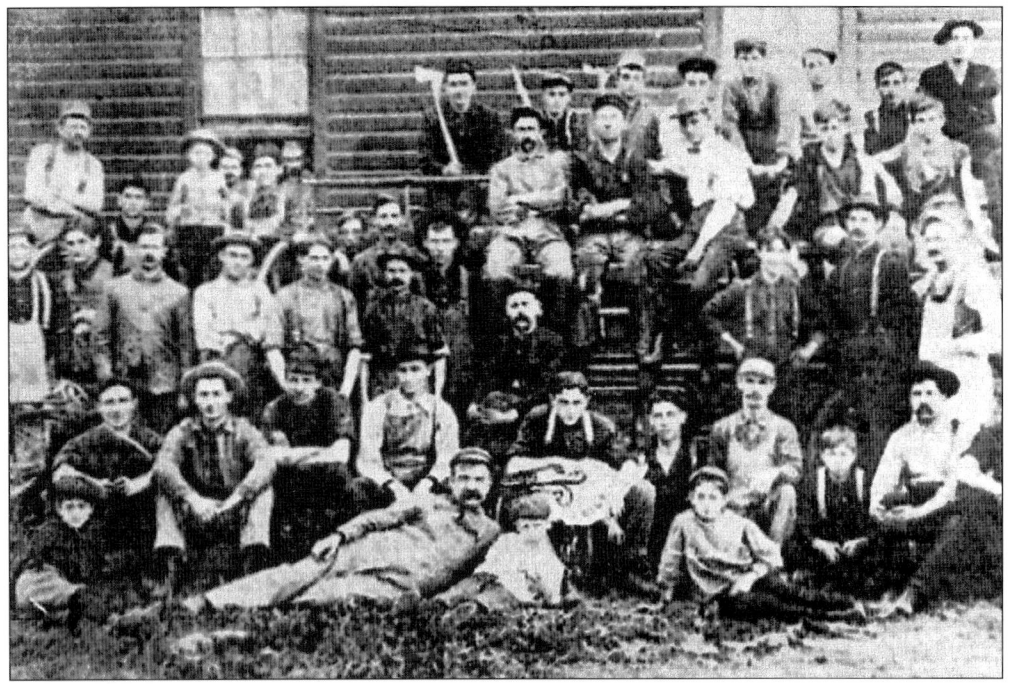

The Ramsey Hand Pump fire engine was stored at the Proudy and Glass Carriage Factory on Sophia Street (Elizabeth Street). The men pictured in this photo were Proudy and Glass Factory workers. When a call went out, the workmen would pull the fire engine by hand to the fire.

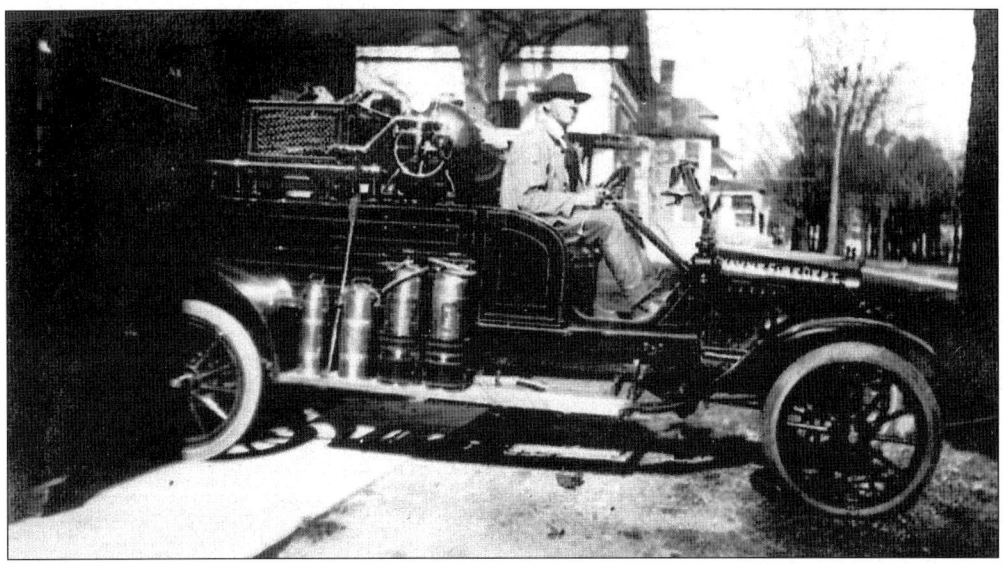

The Village of Wayne formed a Volunteer Fire Department in 1911, under the direction of Fire Chief Charles Goudy. In the year 1917, the first motorized truck was purchased for the fire department. It was a 1917 Ford Model-T hose and chemical truck. Chief Goudy is sitting in the driver's seat.

11

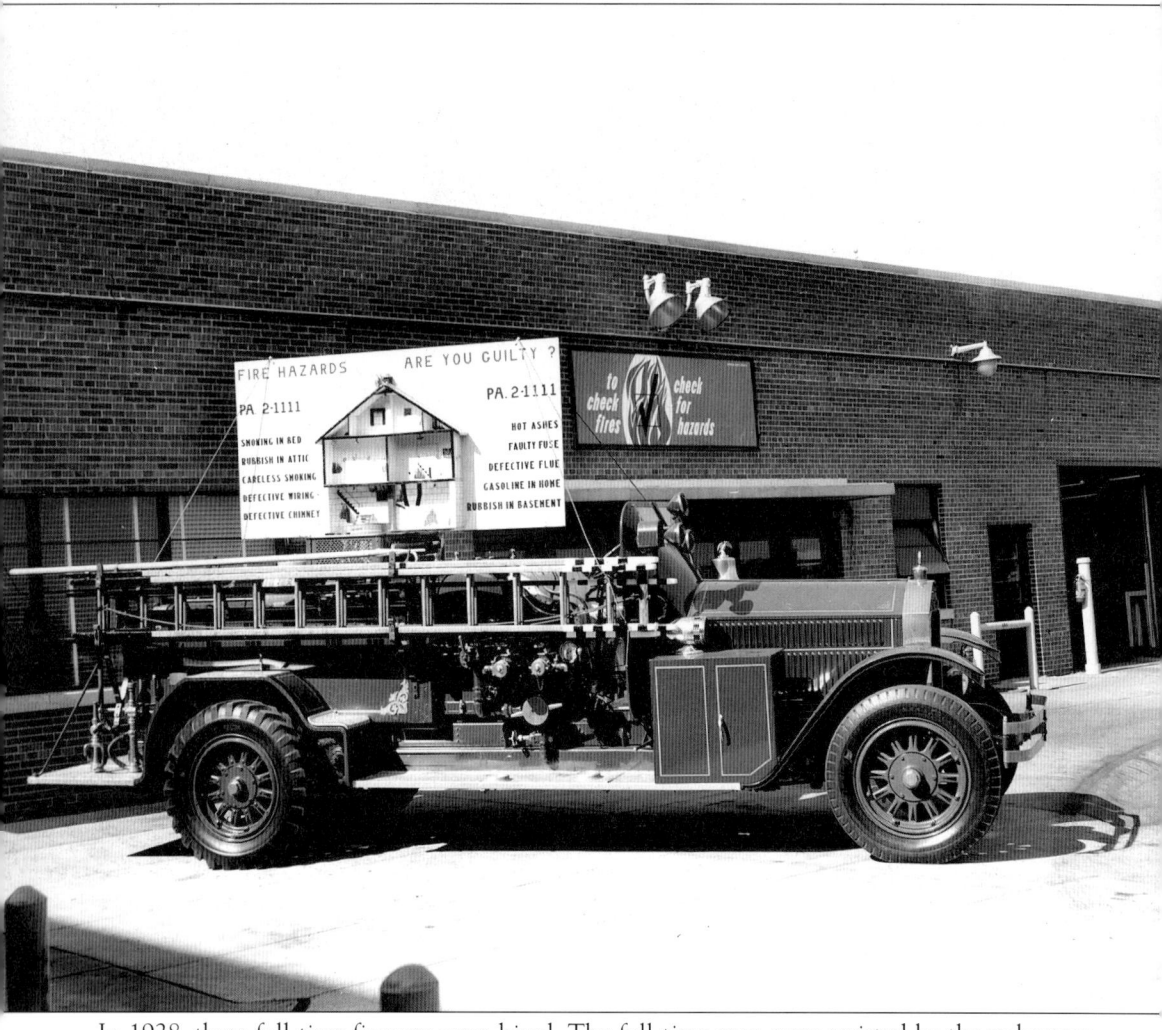

In 1928, three full-time firemen were hired. The full-time men were assisted by the volunteer firemen. A 1928 American La France 1,000-gallon-per-minute pumper was purchased at a cost of $12,000. Arriving in Wayne on June 17, 1928, it was the first such fire truck in western Wayne County. The full-time firemen were Charles Goudy, Dan Doletzky, and Hank Goudy. This fire truck remains with the WFD in 2004.

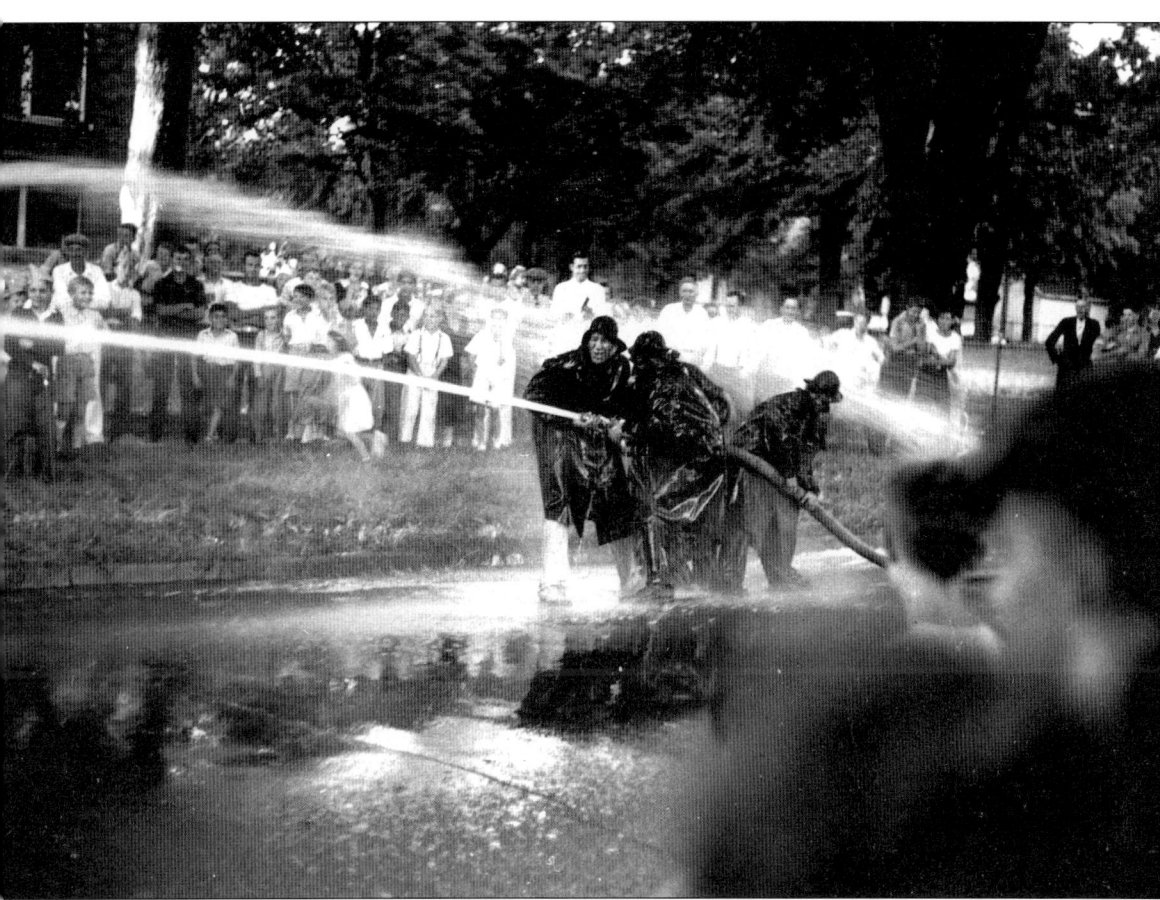

This photo was taken on August 12, 1938, at the Village Summer Festival. Wayne firemen hold a water fight against an unknown fire department. The firemen would run 100 feet, pulling a hose, and hook the hose to a fire hydrant, turning on the water and blasting the opposing team until one or the other fell. The photo was taken on Main Street just west of Sophia Street. Note the old Roosevelt School in the background.

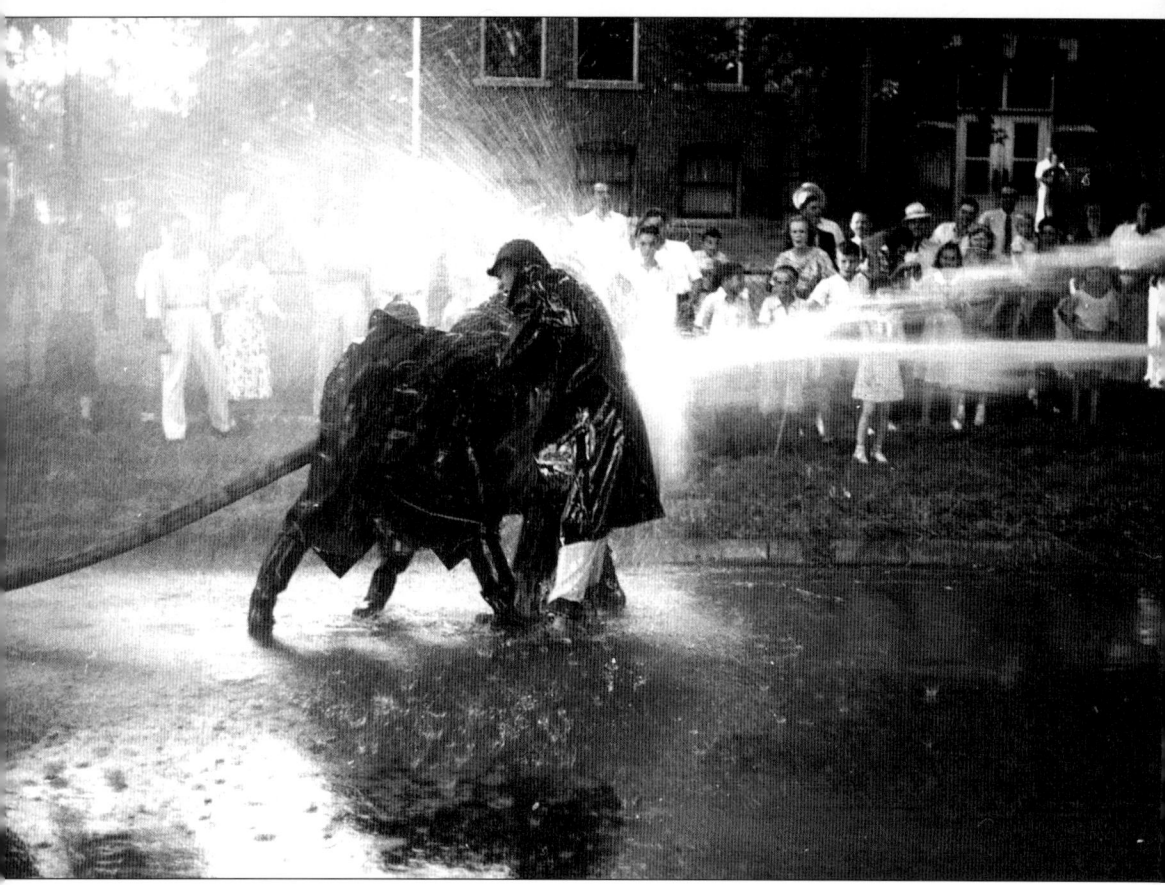
In this photo it looks like the other department is getting the best of the Wayne firemen. Again, note the old Roosevelt School in the background.

Two
1938–1960s

After the Village of Wayne Fire Department had its start as a volunteer fire department in 1911 and became a full-time fire department in 1928, it was called upon to respond to Nankin Township, which had no fire department. For a few years, the Village of Wayne Fire Department would respond into Nankin Township for fires if they were first paid $50, a practice which stopped many persons from calling for help. The State Fire Marshal office put a stop to the fee.

On April 1, 1942, the Village of Wayne and Nankin Township signed a contract forming the Wayne-Nankin Fire Department, which would provide fire protection to a 42 square mile area. Fire Chief Charles Goudy passed away on October 7, 1938, at age 64. Charles had served with the Wayne Fire Department for 24 years.

Charles' son, fireman Hank Goudy, was named Fire Chief in 1928. Hank would serve as the fire chief of the combined Wayne-Nankin Fire Department, which remained in effect for 18 years until it was dissolved in 1960. Nankin Township built its first fire station in 1950 on Ford Road. This station was known as Wayne-Nankin Fire Department Station-2.

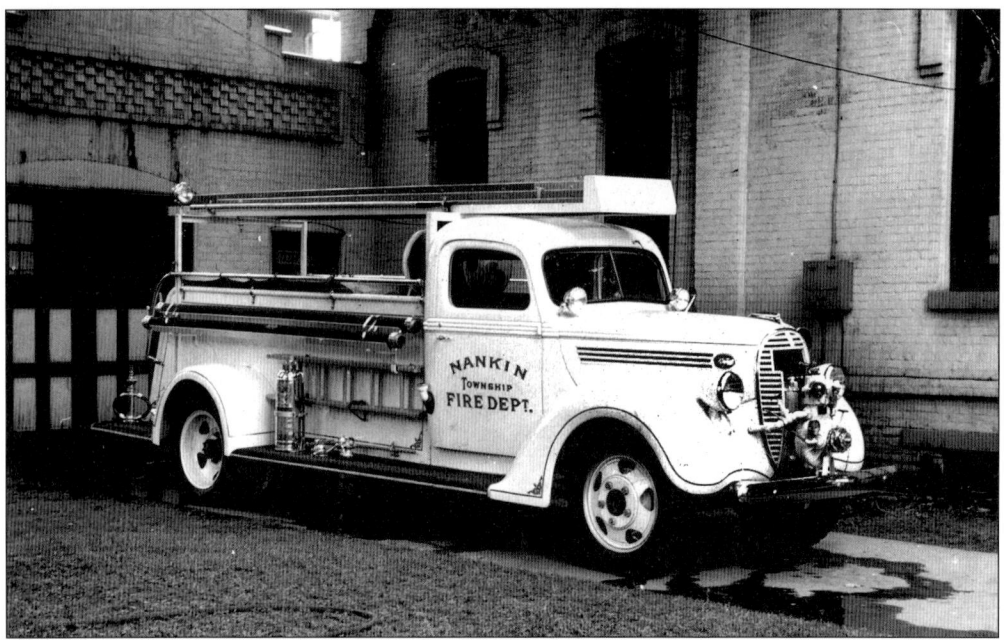

This fire truck became known as the "White Truck." Nankin Township purchased this 1938 Ford F-7 American fire truck as the township's first fire truck. It was used by the Wayne-Nankin Fire Department and responded to calls in Nankin Township. The truck was built in Battle Creek, Michigan.

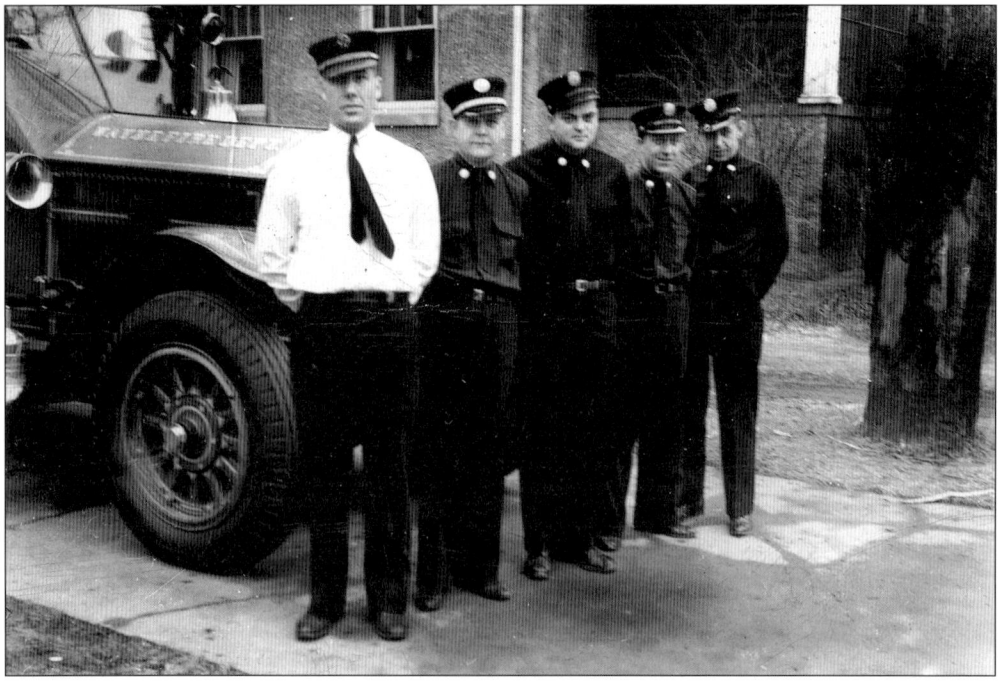

Members of the Wayne-Nankin Fire Department pose with the 1928 American La France pumper. Pictured here are Fire Chief Hank Goudy, Lt. Dan Doletzky, Gerald Kingsley, Richard Hoffman, and Thorton VanDerVoort.

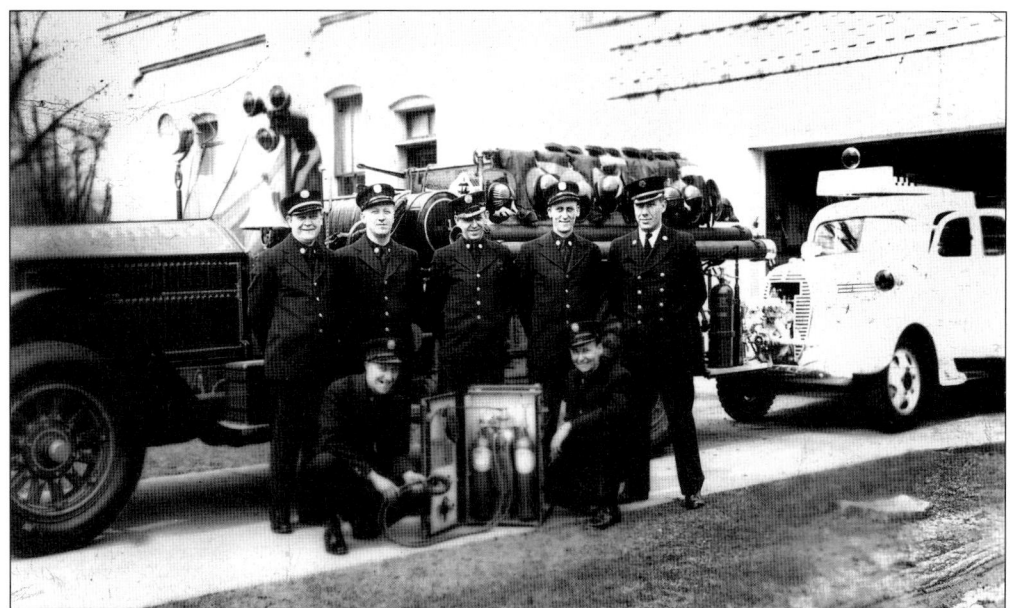

This photo shows the fleet of Wayne-Nankin Fire Department in 1942, as a fireman shows off the new resuscitator that was donated by the Wayne High School Senior Class of 1942. From left to right, they are as follows: (back row) Lt. Dan Doletzky, Warren "Whitty" Robinson, Thorton VanDerVoort, William Dittmar, and Fire Chief Hank Goudy; (front row) Richard Hoffman and Forest Moody. The photo was taken on the south side of the Village Hall.

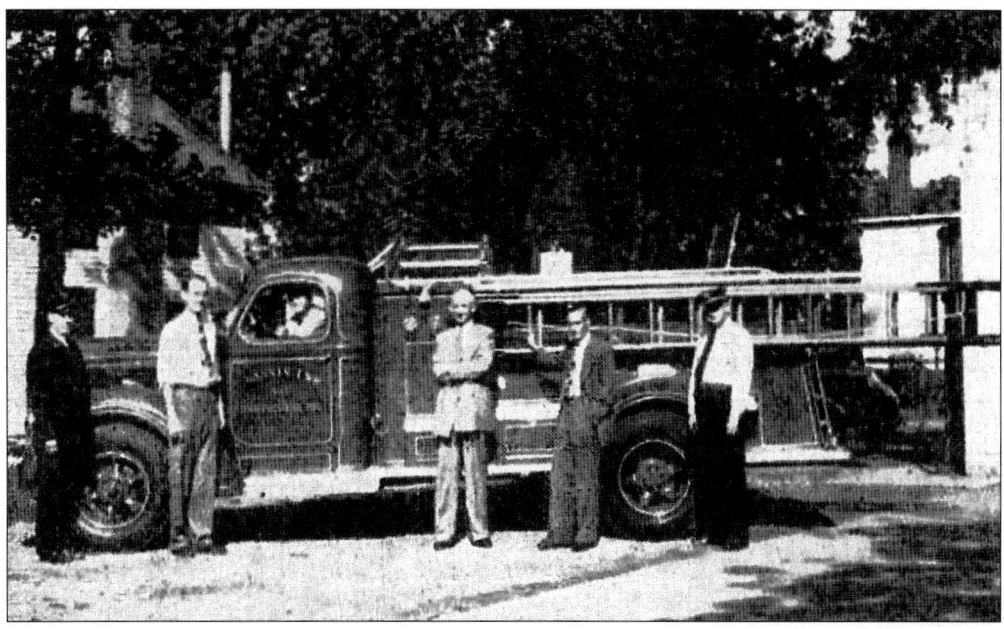

The first new fire truck purchased by Nankin Township for the Wayne-Nankin Fire Department was this 1947 International John Bean high pressure pumper made in Lansing, Michigan. Pictured from left to right are: Fire Chief Hank Goudy; Wally Arrowsmith, Nankin Township Treasurer; Lt. Dan Doletzky (in truck); Nankin Twp Clerk Harvey Ahrens; Nankin Township Supervisor Sherman L. Bunnell; and Gerald Kingsley.

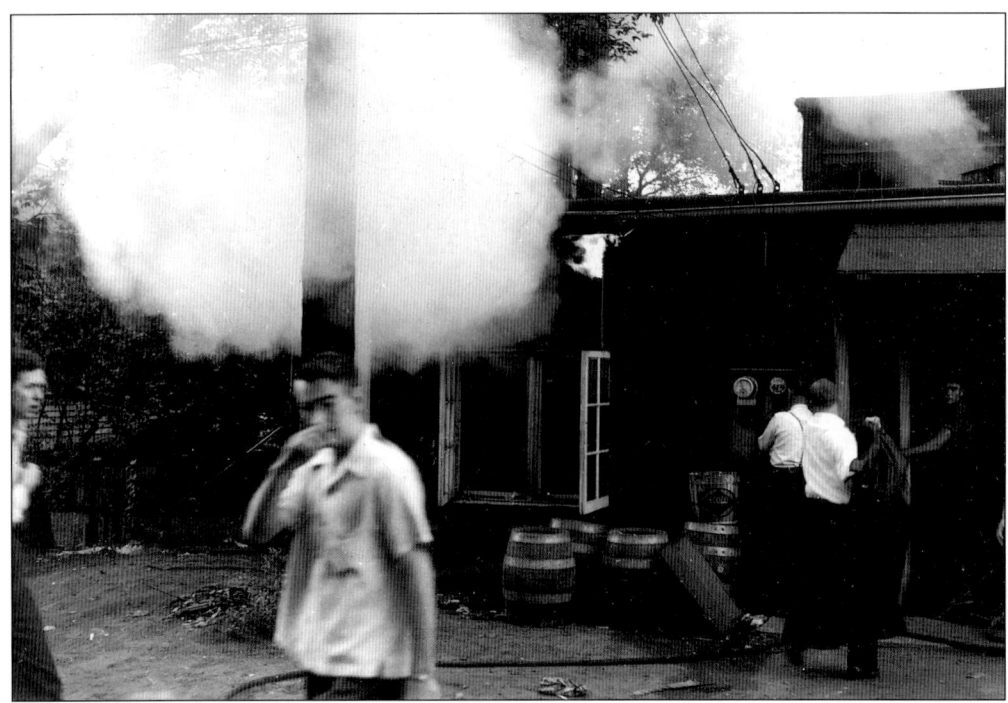

In July of 1941, fire struck the rear of the Club Restaurant on the south side of Michigan Avenue, between Wayne Road and Park Street. It appears as if Wayne residents had little to do on this day.

The 1928 American La France pumper responded to the Club Restaurant to battle the blaze.

This picture shows a bus fire at 34111 Michigan Avenue at Sims Sreet. In the driveway at the rear of the fire truck is a Wayne police car. At the rear of the bus is a Wayne County sheriff car. A Wayne police officer stands next to the rear of the fire truck. To his right is a Wayne County sheriff deputy.

The 1947 Kaiser Frazer Chief Car is in the background of this photo, taken in 1949. Pictured from left to right are Lt. Dan Doletzky, Ralph Renton (Team One), Warren "Whitty" Robinson, Richard Hoffman (Team Two), and Fire Chief Hank Goudy.

19

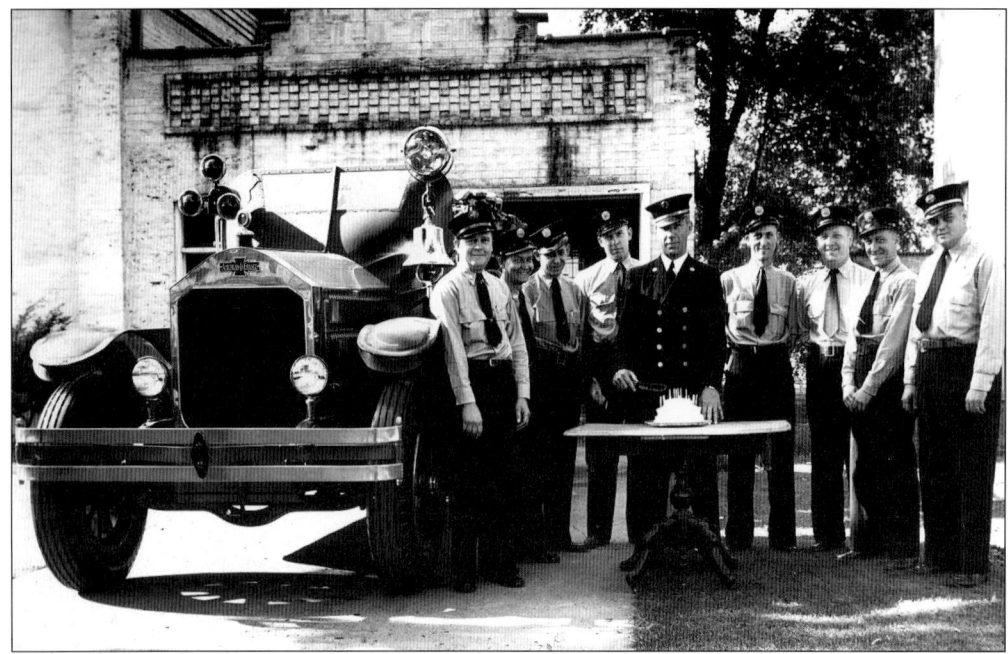

The firemen of the Wayne-Nankin Fire Department celebrate the 21st birthday of the 1928 American La France pumper in 1949. Pictured from left to right are as follows: Lt. Dan Doletzky, Forest "Bud" Moody, Thorton VanDerVoort, Wagner, Chief Hank Goudy, Bill Dittmar, Warren "Whitty" Robinson, Richard Hoffman, and Gerald Kingsley.

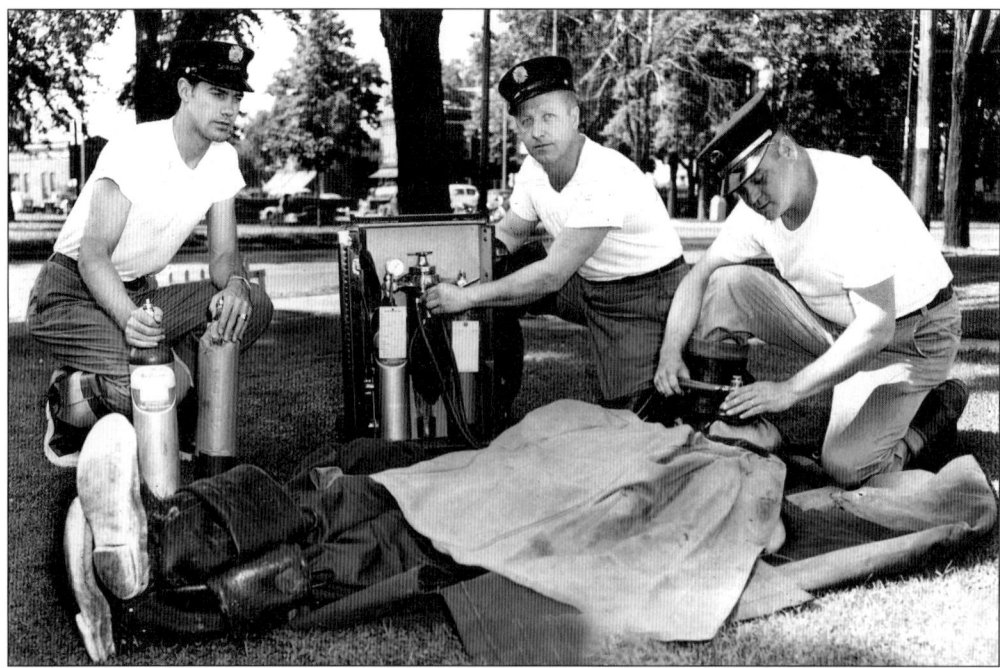

This photo appeared in the *Wayne Graphic* in August of 1951. Firemen train in the use of the resuscitator. They are, from left to right: Ralph Renton, Warren Robinson, Lt. Gerald Kingsley, and Russ Johnson. Johnson is acting as the victim in this exercise.

Firemen train in the use of the self-contained breathing apparatus. Russ Johnson has the air pack on, Ralph Renton is on the left, and at right are Warren "Witty" Robinson and Lt. Kingsley.

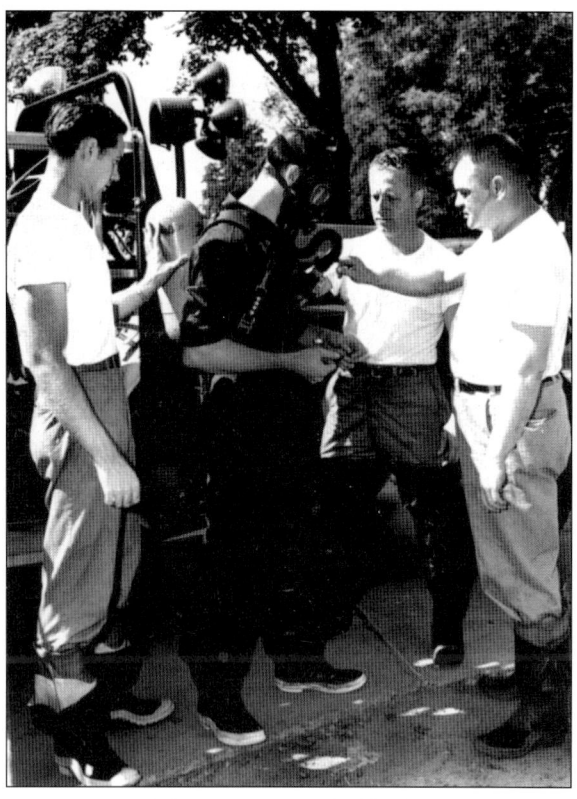

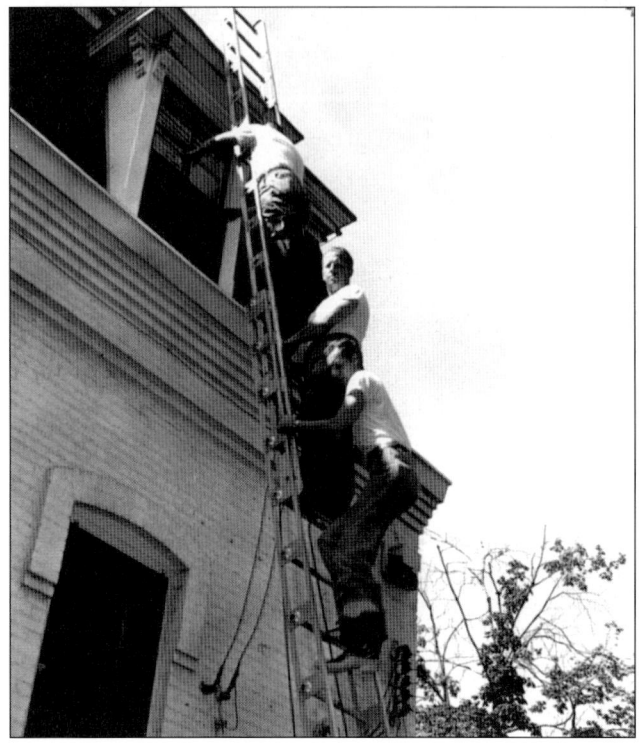

Training never stops ladder training. In this photo taken outside of the fire station, Lt. Kingsley is at the top, Robinson is in the middle, and Renton is at the bottom.

21

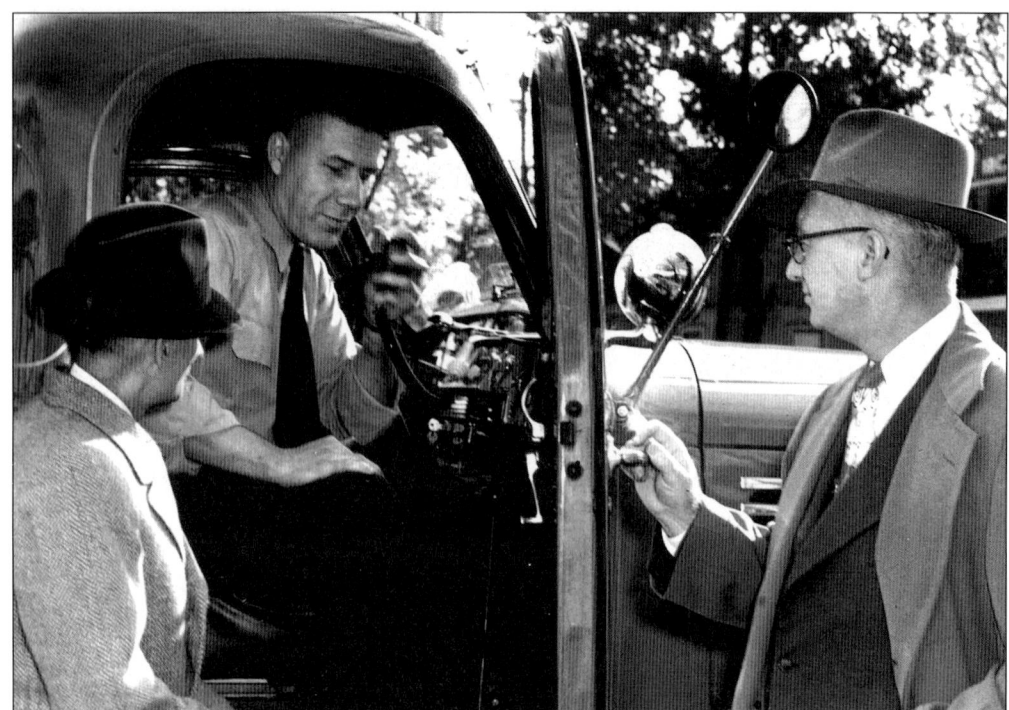

Fire Chief Goudy shows Nankin Township Supervisor Sherman L. Bunnell and Village President Wilson McCormmic how the new two-way radio works. Wayne Fire Department is known as Base-2 and broadcast on 154.370 in 1950.

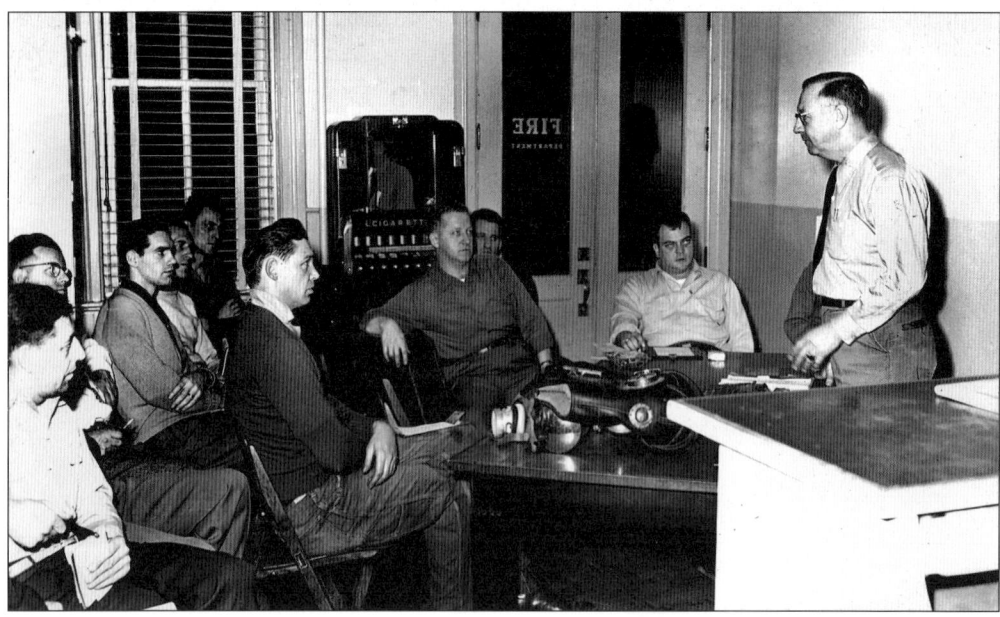

The lobby of the Wayne Fire Station serves as a classroom. Wally Gannon of the University of Michigan instructs. Also pictured are VanDerVoort, Jack O'Callaghan of the Garden City Fire Department, Deauner of the Inkster Fire Department, Renton, Johnson, Dittmar, Robinson, Savini, and Kingsley.

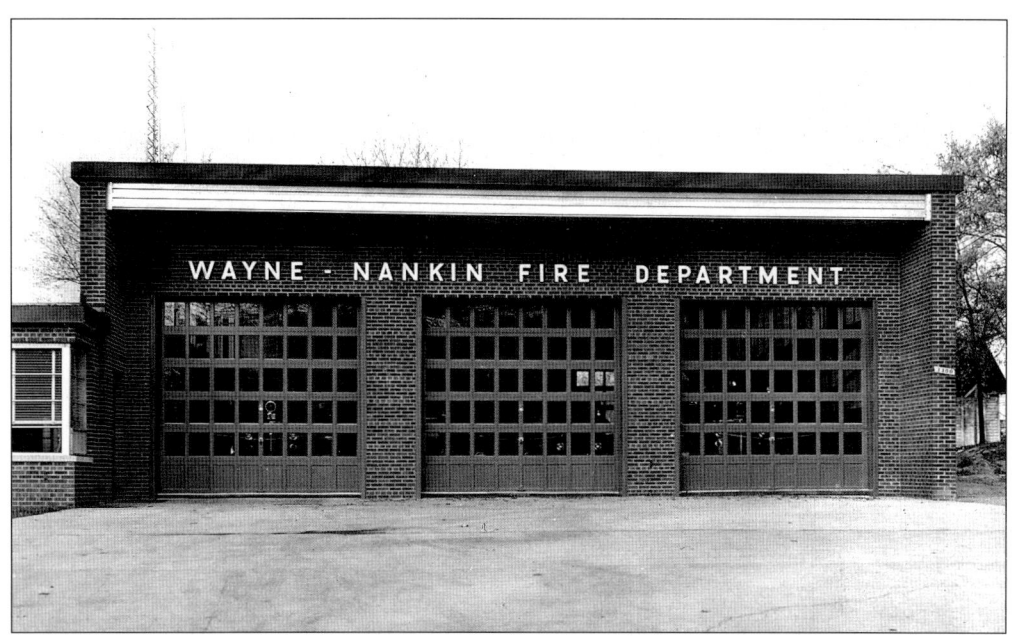

The new Wayne Fire Station at 3300 Wayne Road, which served as the Wayne-Nankin Fire Department headquarters, is pictured here. Opened in 1952, the building itself cost $104,010.98, and $3,472.31 to equip. The Village of Wayne and the Township of Nankin shared the cost.

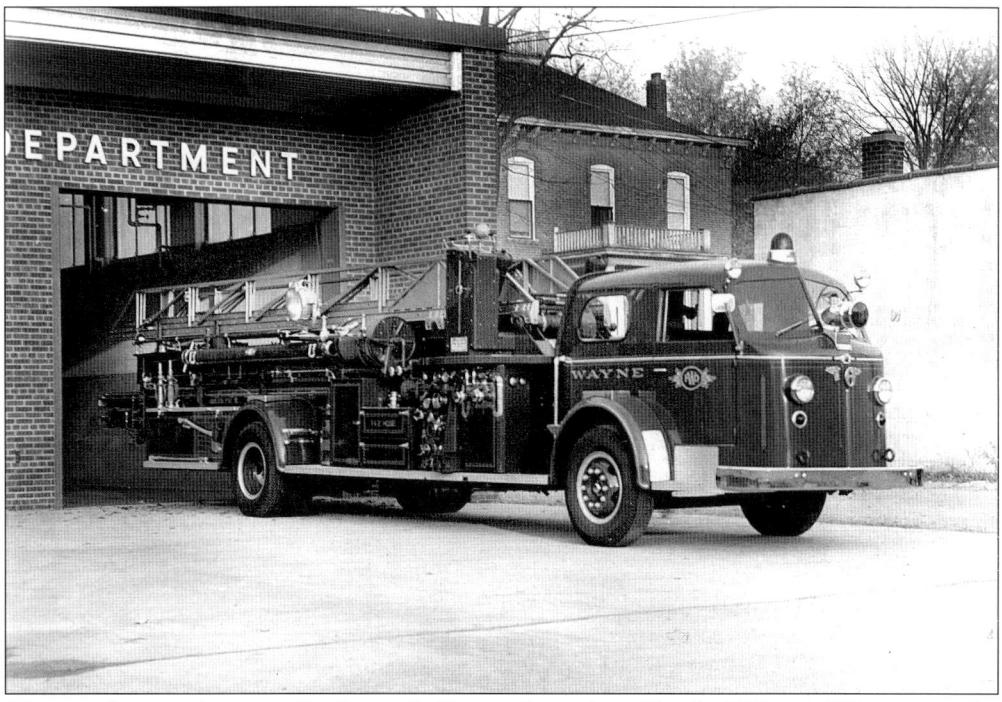

This was the new American La France ladder truck purchased by the Village of Wayne in 1953, at a cost of $37,261.65. The truck had a 1,000-gallon-per-minute pump and a 75-foot aerial ladder. It was placed in service on January 3, 1953, and remained in service until 1978 when it was sold to Hinsdale, Illinois, at $25,500.

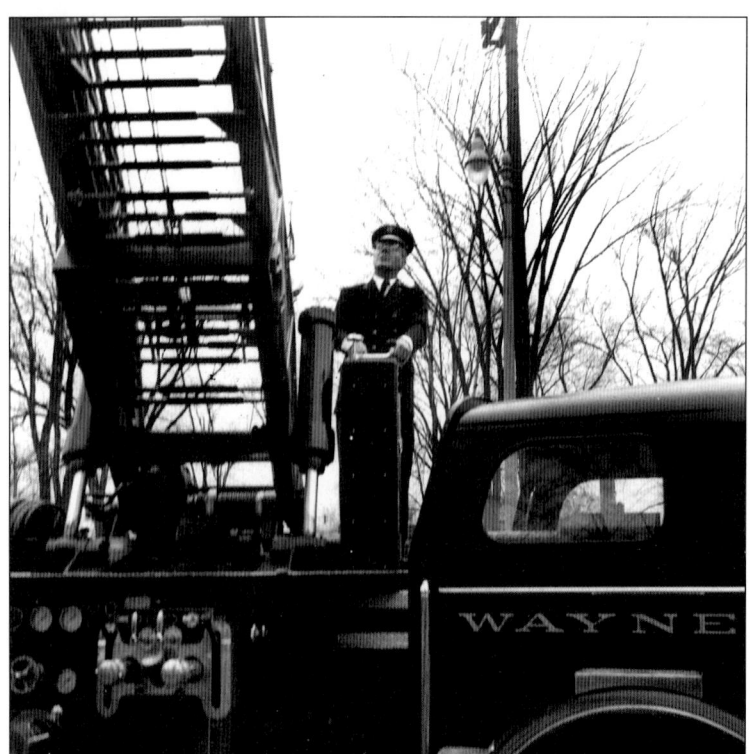

Fire Chief Hank Goudy is pictured at the controls of the new American La France ladder truck.

Fire Chief Hank Goudy and Village of Wayne and Nankin Township officials are pictured with the new American La France ladder in front of the fire station in the Village Hall.

This is the 1953 American La France ladder truck just after arriving in Wayne, sitting on Wayne Road across the street from Village Hall. This photo was taken looking north on Wayne Road.

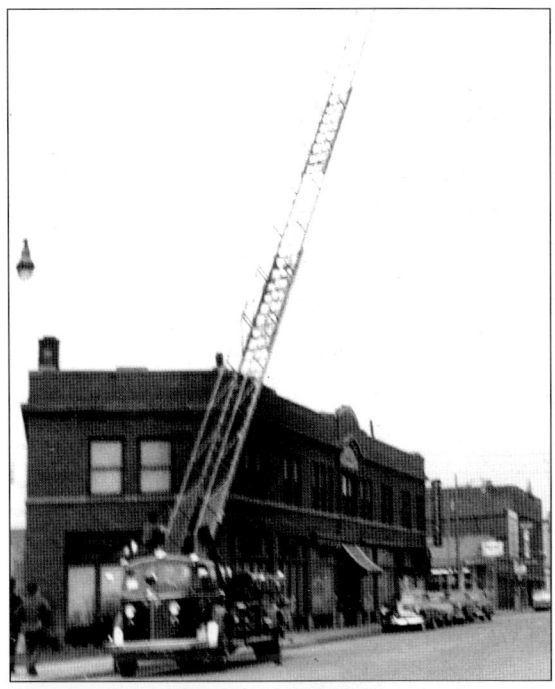

The Village of Wayne received a new fire truck in 1953. This 750-gallon-per-minute pumper was built by American La France and cost a total of $16,672.79. The cost was shared by the Village of Wayne, which paid $5,372.40, Nankin Township, which paid $5,372.39, and the State of Michigan Civil Defense, which paid $5,928. The Village of Wayne was the owner of the fire truck.

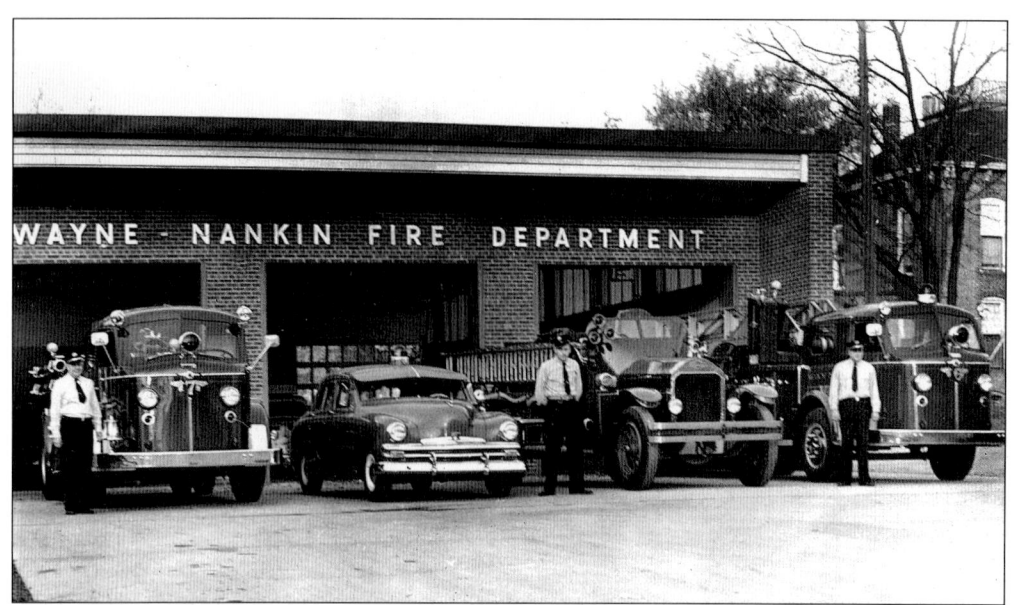

This is the fleet just after moving into the new station. From left to right are Lt. Dan Doletzky, Milton Quiring, and Lt. Kingsley. The trucks are the 1953 American La France pumper, the 1947 Kaiser-Frazer Car, the 1928 American La France Pumper, and the 1953 American La France Ladder.

This photo depicts Sunday morning training in the municipal parking lot on Sims, west of Wayne Road. Lt. Kingsley is on the ladder, Chief Goudy is standing on the rear of the ladder truck, and on the ground wearing a cap is Robinson. The car is a 1954 Mercury station wagon.

During training for Station-2 on July 20, 1954, firemen practiced putting out gasoline fires in a pit dug in a field next to Station-2. Chief Goudy is in the white coat.

Chief Goudy watches Vincent and Noel Brown extinguish the fire during training on July 20, 1954.

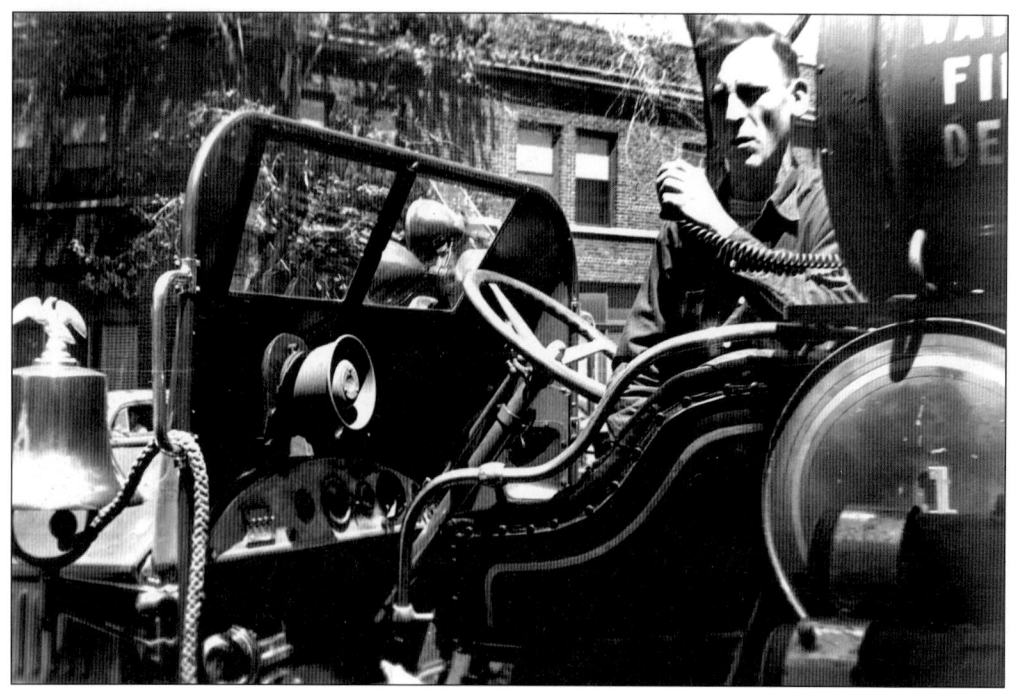

Fireman Bill Dittmer tests the two-way radio on the 1928 American La France pumper.

The first volunteer firemen at Wayne-Nankin Fire Department Station-2 on Ford Road, the first fire station built by Nankin Township. The men receive training from Chief Goudy, Tom Reynolds, Joe Clement, Wally Newlin, and Dan Doletzky.

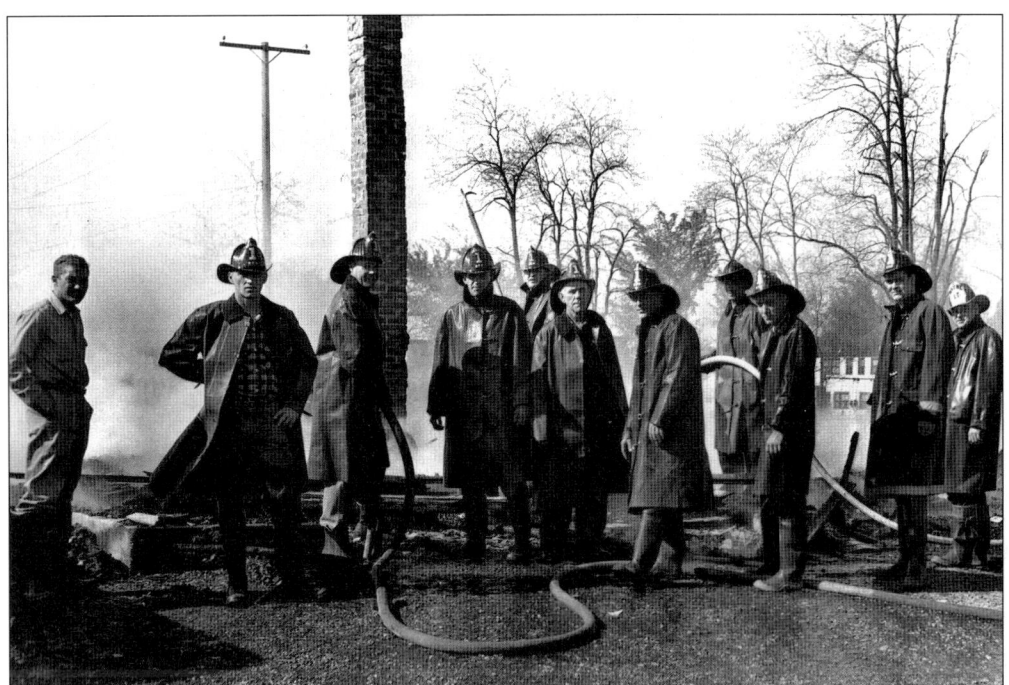

The Norwayne supply shed, located at Venoy and Dorsey Roads, burned on May 8, 1955. From left to right are firemen Ralph Covelle, Neil "Smokey" Gogolin, Leon Maddle, Rod Vanderhill, Herman Gainer, Joe Romazt, Bill Wollenberg, Harold Batman, Don Edmonds, Spencer Schafer, and Lt. Gerald Kingsley.

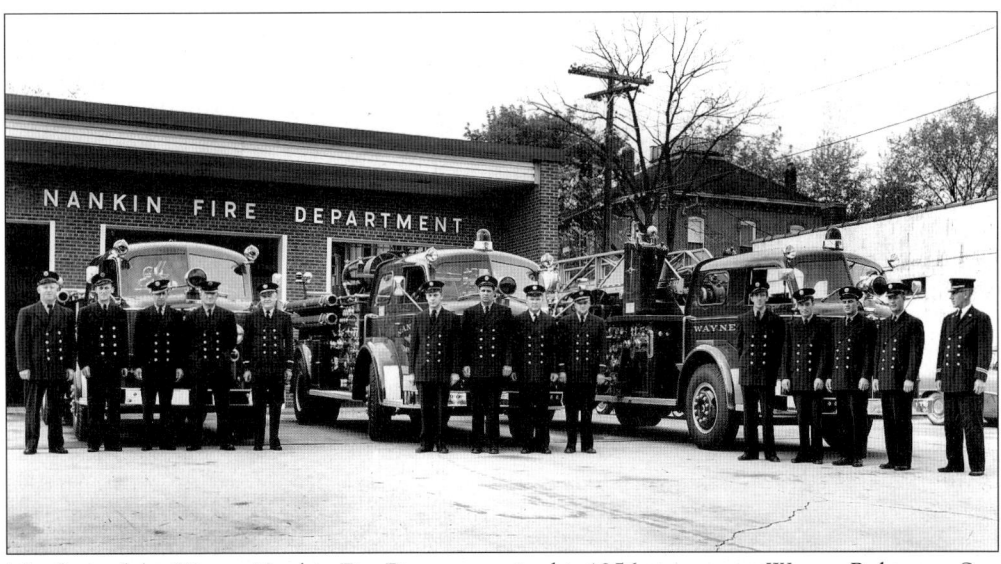

Members of the Wayne-Nankin Fire Department in this 1956 picture are: Warren Robinson, Sgt. Bill Dittmar, Sgt. Thorton VanDerVoort, Ralph Savini, Lt. Dan Doletzky, Robert Taylor, George Gunther, Esco Thomas, Lt. Gerald Kingsley, Russ Johnson, Don Edmonds, Carl Holsten, Neil Prieskorn, and Chief Hank Goudy. The firemen in the photo were the full-time members of the Wayne-Nankin Fire Department. Behind them are the following apparatuses: 1953 American La France pumper, 1954 American La France pumper, and 1953 American La France ladder truck.

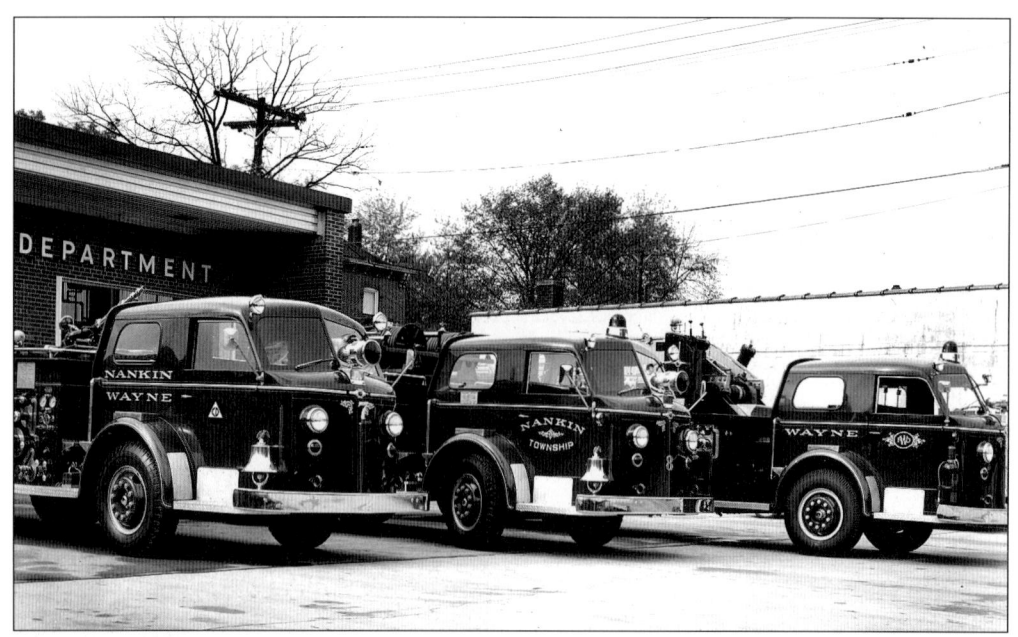

Within the fleet of the Wayne-Nankin Fire Department in 1956 were: Engine-7, a 1953 American La France 750-gallon-per-minute pumper; Engine-8, a 1954 American La France 750-gallon-per-minute pumper; and Ladder-6 1953, an American La France 1000-gallon-per-minute pumper with a 75-foot aerial ladder.

In this picture taken April 13, 1959, firemen Jim Allen and John Bayne of Station-2 battle the fire at Joe's Crown Market at 36313 Ford Road in Nankin Township.

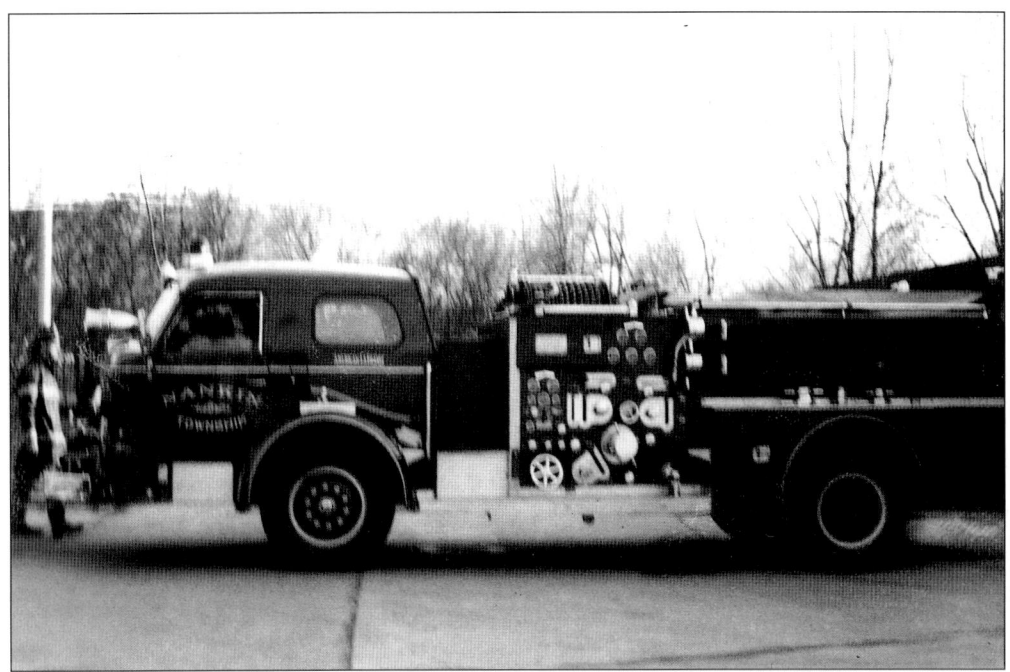

This new fire truck, a 1956 American La France 1000-gallon-per-minute pumper, was the fourth fire truck purchased by Nankin Township for use in the Wayne-Nankin Fire Department.

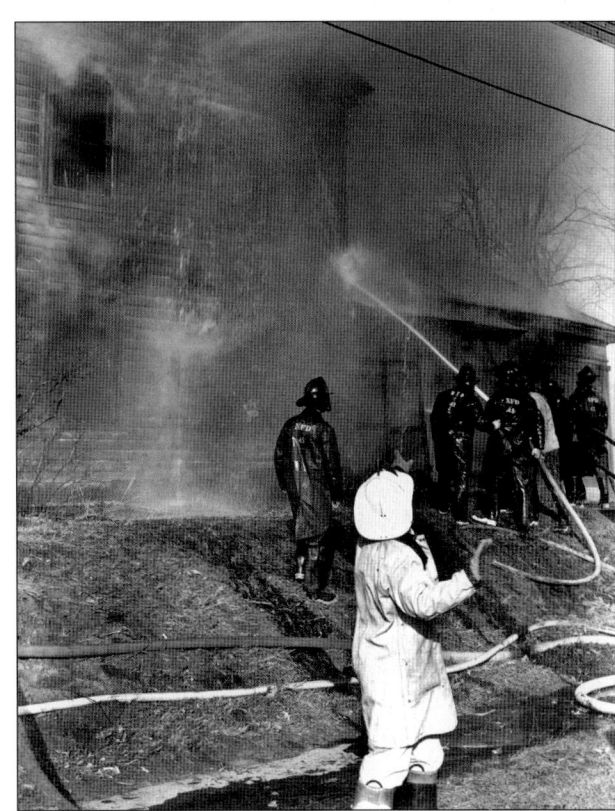

Fire Chief Hank Goudy (wearing a white coat) directs firefighters battling a house fire on Michigan Avenue at Purshing Street in October 1957. Firemen from Station-4 are seen with the hose lines.

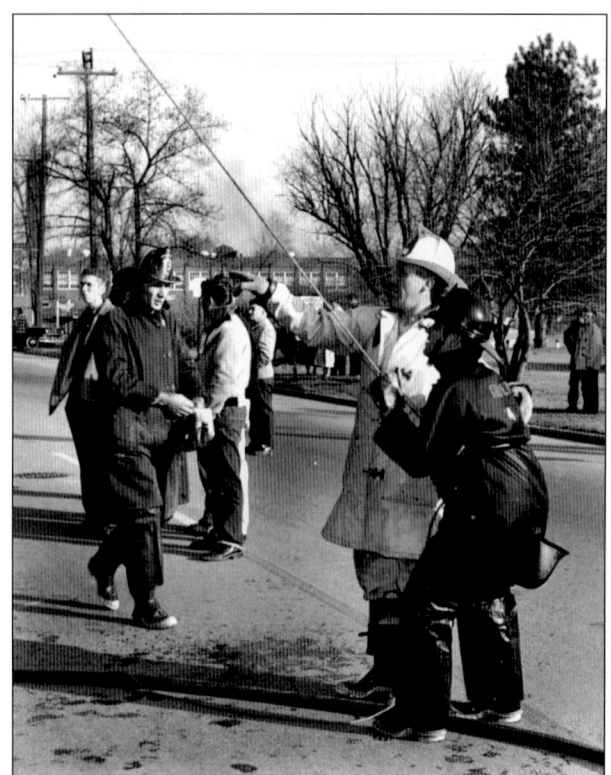

Fire Chief Hank Goudy assists fireman Rick Grejack in directing the line fastened to the nozzle of the ladder truck. Fireman Tom Posler is approaching from the left. The old Wayne High School is in the background.

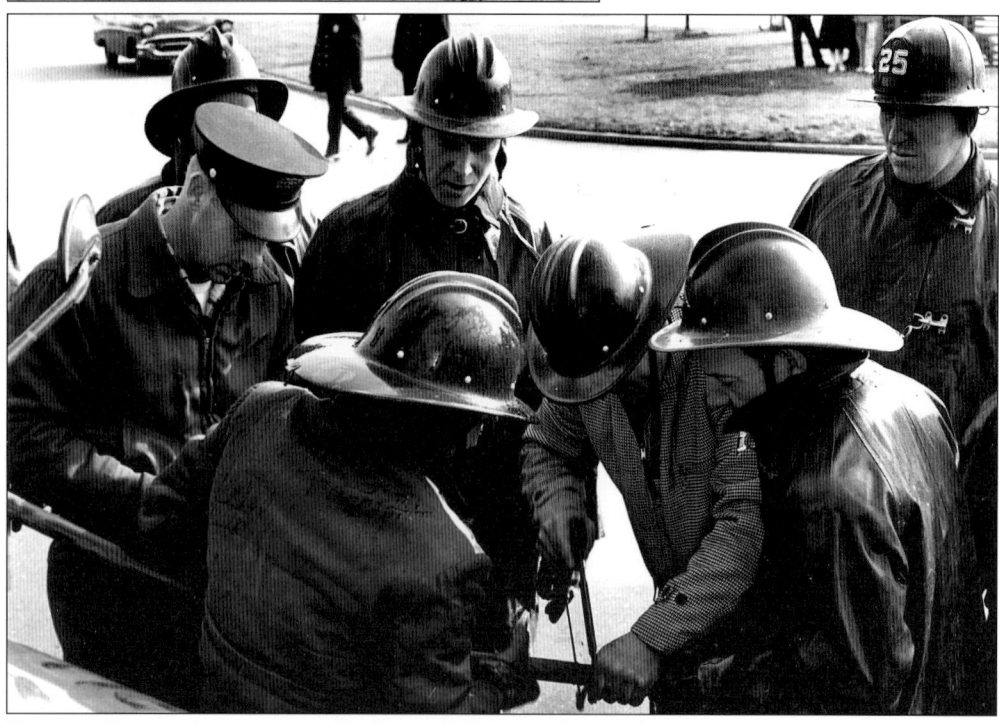

Fireman Quiring (wearing a cap) directs repairs made to a booster line by volunteer firemen Noel Brown and Joe Clements. Two Wayne police officers can be seen in the rear.

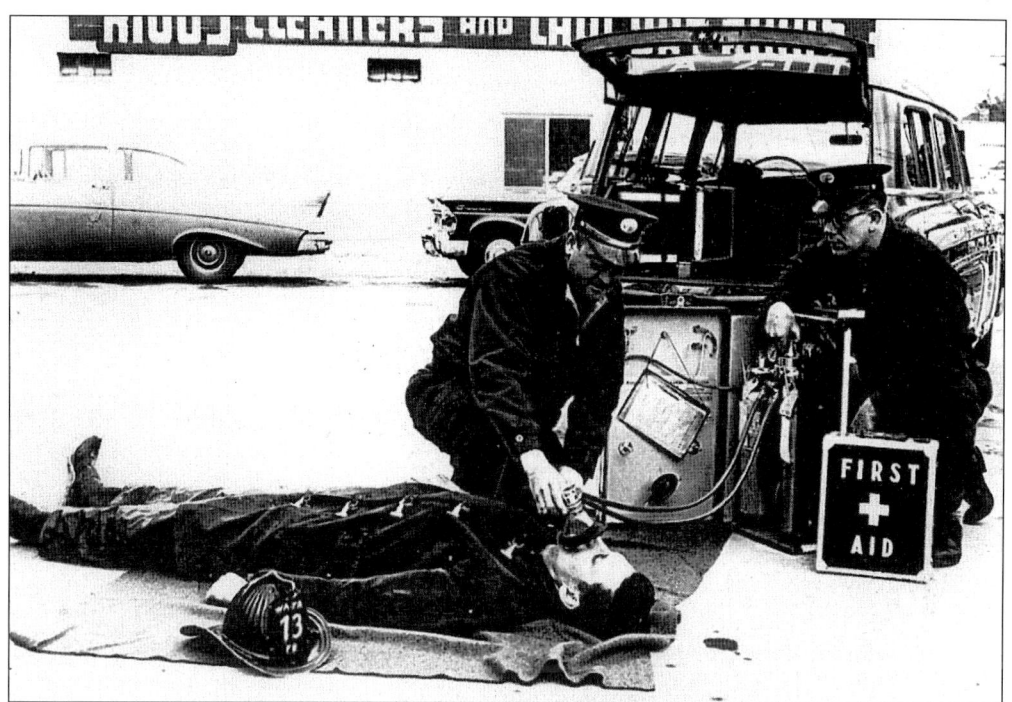

Lt. Gerald Kingsley and Owen McGill give oxygen to fireman Tom Posler in front of the fire station as part of a training exercise. The old Riggs Cleaners can be seen in the background.

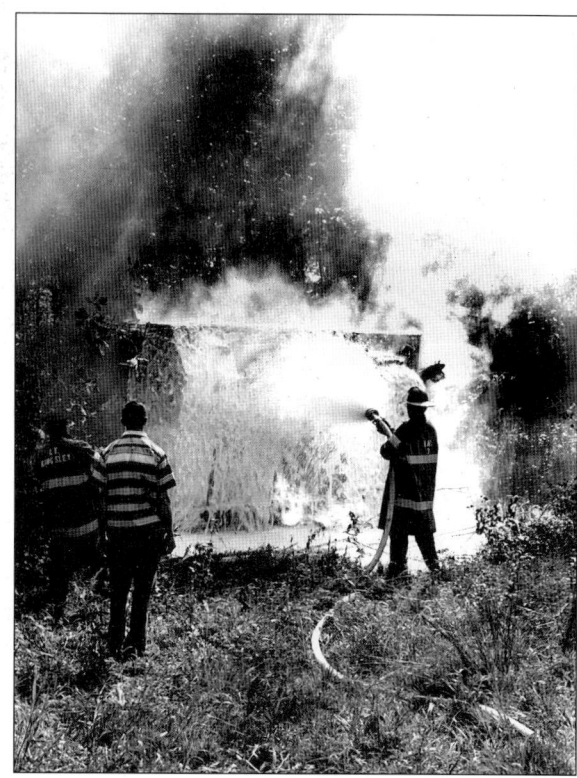

Firemen battle an Army Tank fire at 35282 Oakwood Lane, on August 28, 1959. The tank was used to pull stumps. Lt. Kingsley is on the left.

On November 9, 1957, Wayne-Nankin Fire Department battled a building fire at Building Materials on Michigan Avenue. Sgt. Thorton Van Der Voort, Frank Perris, Rick Grejak, Dick Nicolle are seen here.

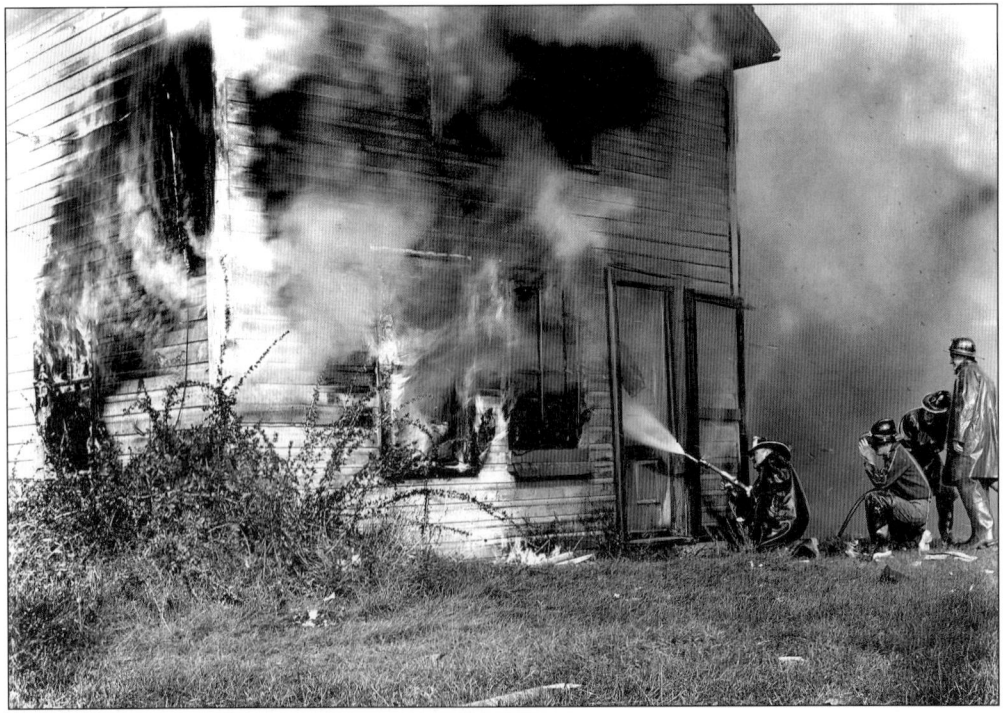

This photo depicts a dwelling fire that occurred on October 31, 1954, on Palmer Road. Lt. Kingsley is on the nozzle.

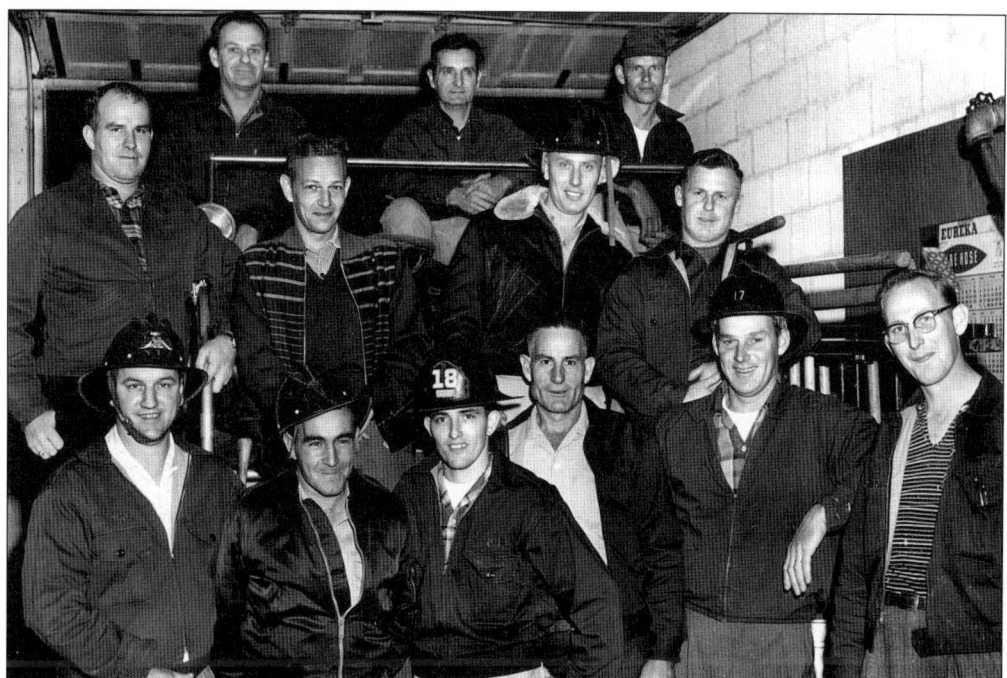

This photo shows the volunteer firemen of Wayne-Nankin Fire Department Station-2, Ford Road. From left to right are the following: (back row) Bob Vincent, Ted Brown, and Roy Berger; (center row) Noel Brown, John Bayner, Ernest Wisch, and Alex Vincent; (front row) Louis Green, Norman Derrick, Ted Blanchard, Jim Allen, Henry Vincent, and Fred Bratby.

This photo shows the volunteer firemen of Wayne-Nankin Fire Department Station-3, Dorsey Road. From left to right are the following: (back row) Bob Mulligan, Joe Romantz, Gerald Kitchen, and Bill Wollenberg; (center row) Chuck Jakaboie, Russ Lincoln, Bill Pountain, Orville Hodder, Pete Spada, and Clare Bierbaum; (front row) Milton Holderness, Bob Hubbard, Irvin Holbrook, and Earl Jacobs.

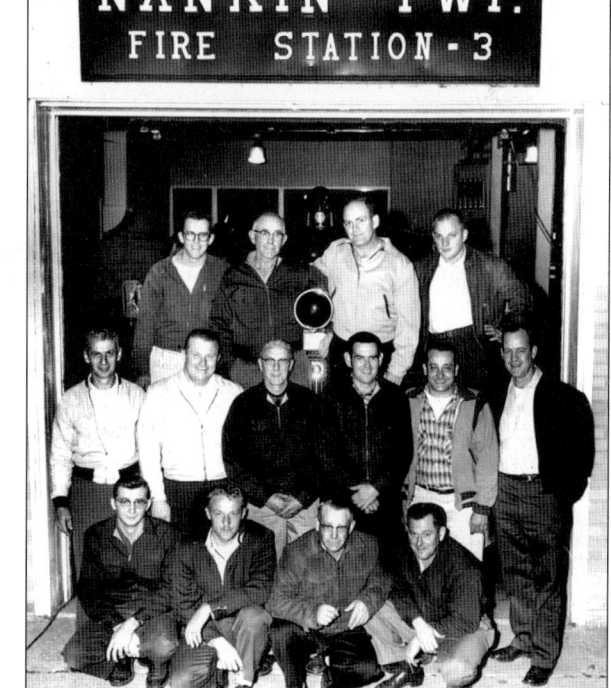

This photo shows the volunteer firemen of Wayne-Nankin Fire Department Station-4, Merriman Road. From left to right are the following: (rear of truck) Arch Arp and G.W. Martin; (on tail board) Larry O'Brien, Chris Zamples, and Jack Wion; (on truck) Joe Benyo, Clearance Bennett; (on floor) Ed Keith, Melvin Gogolin, Steve Toth, John Metter, Harold Blake, and Everett Scharphorn.

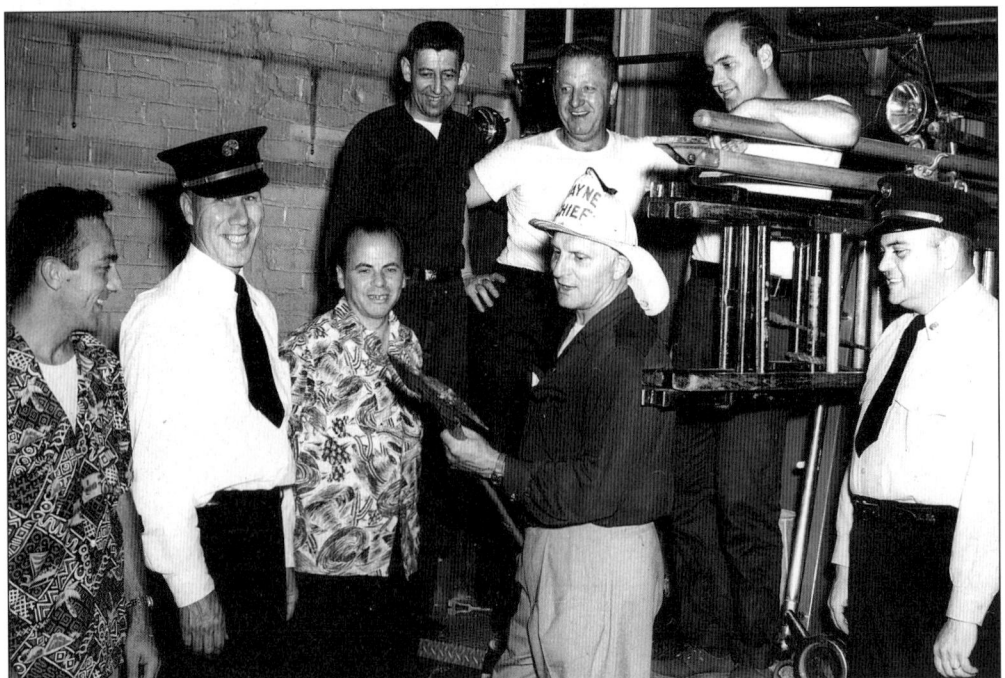

Wayne-Nankin Fire Department made baseball player Billy Rogell Honorary Fire Chief in 1952. Seen in this photo are: unidentified, Chief Goudy, Chum Stockwell, Thorton Van DerVoort, Whitty Robinson, Carl Holston, Billy Rogell, and Lt. Kingsley.

Sergeant Owen McGill instructs volunteer fireman Larry O'Brien on the use of SCBA.

Firemen Tom Posler and Richard Norman battle a fire in a vacant house in July of 1956.

37

Firemen battle a dwelling fire on Clinton Street on October 4, 1959. This was a display put on for the public for Fire Prevention Week.

This October 4, 1959 photo shows firemen Simonds and Grant Pepin battling the Clinton Street Fire.

On March 18, 1959, Wayne-Nankin Fire Department responded to a fire in a rooming house at 4042 South Wayne Road at Brush Street. Firemen rescued two men from the window, where the spotlight is shining, by use of a ground ladder. Many other persons were removed from the dwelling by the stairway.

Wayne Police Sergeant Walter McGregor questions Harvey Thompson (at right), the owner of the rooming house, on the night of the fire at 4042 South Wayne Road.

Fire Marshal Dan Doletzky (left) directs volunteer firemen Milt Holderness, Gerald Kitchen, and William Wollenberg at the rooming house fire on Wayne Road. Lt. Dittmar and Sgt. VanDerVoort are in the rear.

Seen in this March 18, 1959 photo are Lt. Bill Dittmar, volunteer fireman Bill Wollenberg, and Gerald Kitchen.

40

This is the Proctor Barn at 2529 South Wayne Road, Alarm-1-108-251, on July 6, 1960.

This is another view of the Proctor Barn fire on Wayne Road.

On May 5, 1960, Wayne-Nankin Fire Department responded to 35827 Rolf to 36003 Rolf on a report of a dwelling fire. Upon arrival, firemen found five homes on fire. The homes were under construction at the time of the fire.

In this photo, the Rolf Street fire is fought by volunteer firemen Joe Romatz, Holbrook, Russ Lincoln, and Gerald Kitchen, as well as full-time fireman Milt Quiring (in cap).

Wayne-Nankin Fire Department driver Richard Norman, Milton Quiring, and Sgt. Russ Johnson (in coat) show off the new fire truck on March 8, 1960. This was the fifth and last fire truck purchased by Nankin Township for use by the Wayne-Nankin Fire Department. Engine-5 was a Seagrave that was assigned to Station-4.

Alarm-1-180-492 at 36000 Schley Street is being fought by firemen on December 25, 1961. Three persons lost their lives in the fire: five-year-old twin girls Glenda and Brenda Wilkinson, and Charles Norwood, age 28.

Volunteer fireman Russ Lincoln is shown on the left as Wayne County Sheriff Deputies remove one of the bodies from 36000 Schley Street to be transported to Wayne County General Hospital by Uht Ambulance Service. Three Wayne County Sheriff Deputies were transported to Wayne County General Hospital by other Deputies, as the officers attempting to rescue the trapped persons were overcome by smoke.

This photo shows the aftermath of the dwelling fire at 36000 Schley Street. Fire Chief Hank Goudy is seen at far right. It is interesting to note how area residents were allowed to walk up to the house, unlike today.

44

The Wayne Fire Department received this 1963 Ford station wagon, which was used to respond to first aid calls.

Lt. Thorton VanDerVoort and firefighter Don Edmonds show off the first aid equipment carried in Car 203, the 1963 Ford station wagon.

45

It looks as if the fire department had just arrived when this photo was taken during the February 5, 1963 fire at the Don Massey Used Car Lot at 33133 Michigan Avenue.

Firefighters were called to the apartment above Chum's Donut Shop at 34619 Michigan Avenue on May 9, 1963. This was Alarm-143, and firefighter Jim Tempet is climbing the ladder.

On April 6, 1964, firefighters responded to Enot Foundry on Annapolis at the railroad for a fire on the roof of the building.

On May 29, 1964, at 1132 hours, Wayne firefighters responded to 4614 South Wayne Road to the Standard Gas Station, known as Alarm-146. Heavy smoke was showing on arrival, and the fire destroyed the garage area.

May 29, 1964 Standard Gas Station fire at Wayne Road and Annapolis. Sgt. Neil Prieskorn at left.

Wayne firefighters attended training at Detroit Metro Airport in October of 1964. The Metro Airport Fire Department trained them on the proper way to attack an aircraft fire. From left to right, are Lt. Robinson of Metro Airport FD, Lt. Thorton Van Der Voort, Lt. Gerald Kingsley, and Lt. Bill Dittmer.

Lt. Robinson of Metro Airport FD watches at Wayne firefighters Lt. Thorton VanDerVoort, Sergeant Neil Prieskorn and George Ferguson attack a fire on October 6, 1964.

It was a cold night on December 3, 1964 when Wayne firefighters were called to Century Supermarket on Wayne Road at Chestnut Street. Lt. Kingsley is on the ground. Sgt. Owen McGill is on the ladder and Wayne firefighters Rick Smith III, Eddie Leonard Volunteer, and Don Edmonds are on the roof.

Wayne firefighter Ken Beasley operates the ladder truck at the Century Supermarket fire.

Fire Marshal Dan Doletzky walks in front of Century Market as two firefighters battle the fire on the left. Note the parking meters.

Wayne firefighters battle a dwelling fire on Park Street in 1965. The house was part of the Urban Renewal Project.

In this May 11, 1965 photo, firefighter Rick Smith III battles a grass fire on Clinton Street west of Woodward Street.

In this January 19, 1966 photo, Wayne firefighters use the Trusadell home for training. The house was to be torn down in the Urban Renewal Project.

This January 1, 1966 photo shows William Withworth, Sgt. Russ Johnson, Don Edmonds, Art Palo, Rick Smith III, and Fred Arthur.

Chief Goudy is on the ladder in this photo from February 14, 1966. Firefighters responded to the Shafer Building on Michigan Avenue due to smoke in the building.

This photo of the Wayne Fire Department was taken August 3, 1966. From left to right are Fred Arthur, Lt. Van DerVoort, Sgt. Russ Johnson, Art Palo, George Ferguson, Hugh Anderson, Don Edmonds, and Fire Chief Goudy. Also seen are the 1962 Ford American La France pumper, 1965 Ford Rescue, 1953 American La France pumper, 1953 American La France ladder, and 1966 Ford station wagon Chief Car.

(*Above left*) Firefighters Terry Tunner (left) and Tom Molitor clean up the fire apparatus bay.
(*Above right*) This 1967 photo shows Russ Johnson, Fred Arthur, and Rick Smith III.

Firefighters were called to Lazar's Clothing Store on Wayne Road between Michigan Avenue and Park Street for a report of smoke in the building. At the ladder controls is Rick Smith III, on the ladder is Sgt. McGill.

On December 28, 1965, Wrigley's Grocery Store on Michigan Avenue at Park Street was in the process of being torn down when a cutting torch set the building on fire. Wayne Bennett is at the top of the ladder.

Firefighters stretch hose to the rear of the building at the old Wrigley's Grocery Store.

Fire Chief Hank Goudy discusses fire safety with the plant foreman at Ford Motor Company. To the chief's right are Russ Johnson, Owen McGill, and Bill Dittmer.

The Wayne Fire Department 1965 Rescue-203 1965 Ford Van, Engine-201 1962 Ford American La France pumper, Ladder-202 1953 American La France. Pictured from left to right are as follows: (front row) Russ Utt and Sgt. Neil Preskorn; (left of engine) Lt. Bill Dittmer; (right of engine) Terry Turner; (middle of ladder truck) unidentified; and (front of ladder) Elmer Daniels.

Three
1970–2003

The City of Wayne Fire Department was started on December 31, 1960, after the Wayne-Nankin Fire Department was dissolved.

The 1970s saw new modern fire apparatus purchased and new fire fighting equipment to keep the firefighters up to date. Firefighters became emergency medical technicians. The 911 telephone systems were started. When the Wayne Department of Public Safety was formed, the Wayne Fire Department changed its name to the Wayne Fire Division.

The 1980s saw the largest fire in the history of the Wayne Fire Department. Firefighters became public education officers, and Wayne Fire Department went into the schools to teach fire safety to community groups.

The 1990s again saw new fire apparatus purchased and training upgraded. The fire department started to provide Advanced Life Support to the community in 1999. And after years of debate, plans were made for a new fire station which was completed and opened in 2003.

Friday, April 16, 1971, was a warm spring day. Wayne Fire Department responded to many grass fires on the right of way of the Con Rail railroad tracks. In this photo, Sgt. Rick Smith III battles a grass fire at Wayne County Road Commission lot, as Fire Marshal Russ Johnson looks on.

The Mercury scrap yard fire on Annapolis at the railroad occurred on Sunday, April 26, 1970. Smoke could be seen from Detroit. Wayne firefighter Don Edmonds connects a supply line to Engine 211 as off-duty Westland firefighter Keith Lincoln assists.

Firefighters Don Edmonds (in cap) and Ken Warfield stretch hose line at the Mercury scrap yard fire, April 26, 1970.

Art Palo (left), Ken Warfield (right), and an unknown firefighter (on ladder) battle the April 26, 1970 Mercury scrap yard fire on Annapolis.

On August 12, 1970, there was a fire at the First Congregational Church. The building was over 100 years old. On the porch is firefighter Joe Kadlec, at the bottom of the porch is DPW foreman Leo Pratt. The police officer is Lt. Ken Taylor, and seen with the hose next to ladder truck (front) are DPW foreman Jim Law and an unknown DPW employee. Wayne police patrolman Ken Beasley is at the controls of ladder truck, on the ladder is firefighter Russ Utt.

Lt. Owen McGill, seen on the south side of the Congregational Church, mans a 2.5 inch line.

60

An unknown firefighter and citizen man a 2.5 inch hand line at the church fire early on. DPW foreman Leo Pratt is standing to the right.

Wayne police patrolman Ken Beasley arrives with the ladder truck from the fire station. Lt. McGill is at the controls. Firefighter Russ Utt is getting the hose ready.

This is a view from the northwest side of the church fire. Firefighter Ken Warfield is on the ground. The firefighter at the bottom of the ladder is unknown, firefighter Daniels is on the ladder, and Russ Utt is on the roof.

Firefighter Russ Utt works the ladder pipe at the church fire, August 12, 1970.

Sgt. Terry Turner and firefighter Wayne Bennett show off Wayne Fire Department's new rescue, the second in the department's history. This 1970 Ford Econline Superior Ambulance was the first red and white rig in the department, and was in part paid for with Federal Highway Funds, at a cost of $9,999.99.

Fire Chief Hank Goudy takes a ride home on his last day of work at WFD, June 30, 1972. Chief Goudy served for 44 years. The Chief rides on the 1928 American La France pumper.

Members of the department in 1971 were, as follows: Fire Chief Hank Goudy, Lt. Owen McGill, Lt. Neil Prieskorn, Lt. George Ferguson, Art Palo, Tom Molitor, Sgt. Ken Warfield, Russ Utt, Paul Burgess, Mike O'Brien, Wayne Bennett, Joe Kadlec, Sgt. Terry Turner, Fred Arthur, Fred Gill, and Fire Marshal Russ Johnson.

On May 7, 1973, Wayne firefighters received assistance from the Romulus Fire Department and the Mutual Aid Fire Squad of Michigan, Inc. at Cook Construction Company at 36502 Van Born Road for a fire in a hot tar tank. Fire Chief Russ Johnson is pictured (with white helmet). Tom Molitor is kneeling, the other firefighters are unknown.

On June 30, 1973, Wayne Fire Department received its third rescue unit, a 1973 Chevy Superior Ambulance. The rig was painted with a white roof, lime green body, and a black strip around the center, and this was removed after it was delivered. Pictured from left to right are as follows: Councilman Matt Tinkham, Councilman Kurt Hidman, Pat Cullen, Tom Reed of the State of Michigan, City Manager Wally Arrowsmith, Councilman Ken McKee, Fire Chief Russ Johnson, and Mayor Paul Lada.

65

These are the Wayne Fire Department's first three rescues, or ambulances. From left, they are the 1965 Ford Econline, 1970 Ford Superior, and 1973 Chevy Superior.

On January 21, 1974, there was a dwelling fire at 36320 Michigan, just east of the C&O Railroad. Fire Chief Russ Johnson talks with the owners as firefighters attack the fire.

In this photo from the spring of 1974, an unknown Wayne firefighter battles a grass fire in the rear of the Wayne Bowl on Michigan Avenue.

Fire Chief Ken Warfield shows off the new 1974 Chevrolet. The new car is painted lime green with a white roof and replaced the car to the right, a red 1971 Ford station wagon.

Wayne police officers Sherman Pruden (left) and Dan Randall (right) watch as Sgt. Wayne Bennett attempts to pry open a van door at a injury car accident at Annapolis and Wayne Road. It was Alarm Number 45-254-321, and occurred on April 12, 1974.

Lt. Owen McGill uses the Jaws of Life on the van door as Sgt. Wayne Bennett looks on.

68

Patrolman Dan Randal watches as Sgt. Wayne Bennett and Fred Arthur get ready to load the victim of the car accident to the rescue truck. An unknown citizen also watches the firefighters.

It was a warm humid day with a threat of thunderstorms in the air on August 13, 1974 as Wayne firefighters arrived to battle a building fire in Northside Hardware on Wayne Road at Glenwood. Westland Fire Lt. Joe Benyo is walking in the photo.

Fire Chief Russ Johnson (in white coat) talks with Assistant Fire Chief Tom Posler of Westland FD at the Northside Hardware fire. Westland firefighters are on the ladder.

Northside Hardware owner Sid Kaplan is on the ladder, firefighter Fred Gill is wearing a coat, and Wayne-Nankin Fire Department former volunteer firefighter Jerry Hickman mans the hose line.

Seen in this August 13, 1974 photo are Northside Hardware owner Sid Kaplan, Chief Johnson, and firefighter Fred Gill. Richard Story is on the roof, working for the Mutual Aid Fire Squad of Michigan, Inc., and is with Art Palo of Wayne Fire Department.

Wayne firefighter Lee Gibelyou and the store owner's son are at the rear of the store; Wayne and Romulus rescues are in the background. Volunteer Hickman changes Gibelyou's SCBA.

Wayne Bennett is seen with the pike pole in this December 20, 1974 image. Don Goodlow (left), Terry Turner, George Ferguson, and Rick Waldrop (with hose) battle a building fire in a lumber yard on Brush Street at Newberry.

On January 16, 1976, a train on the Penn Central Railroad struck a pick-up truck. Wayne firefighters give aid to the driver of the truck. Corporal Bill Biggerstaff of Wayne Police Department is at left, along with the two train conductors and engineer. Firefighter Tom Molitor is facing the camera. The accident took place on Elizabeth Street.

A Wayne firefighter loads the truck driver into the ambulance. The woman walking next to the rescue was Mrs. Kruger, a teacher at Roosevelt School, who stopped to give the truck driver a blanket.

In October of 1975, a fire in Hickory Hollow took the lives of a mother and her two children. Lt. Mc Gill (on ladder) Fire Chief Jack O'Callaghan (of Mutual Aid Fire Squad of Michigan, Inc.), and Fred Gill of Wayne Fire Department remove one of the bodies as the medical examiner stands at bottom of ladder. Westland Fire Department, Romulus Fire Department, and the Mutual Aid Fire Squad of Michigan, Inc. fought this fire.

Firefighters Russ Utt and Fred Gill remove snow from fire hydrants, winter of 1976.

Firefighter Don Goodlow checks on dinner at the fire station.

On December 14, 1976, Wayne Fire Department responded to Lazar's Apartments on Michigan Avenue for a fire in an apartment. Firefighters rescued one person from this fire. Westland firefighters Latrell and Day battle the fire from the rear. The Mutual Aid Fire Squad of Michigan, Inc. also assisted at this fire.

This New Year's Eve photo shows a Wayne firefighter battle a dwelling fire on Maple Street. Firefighter Daniels is at the window. Arthur and Fire Marshal Preiskorn are to the right.

This photo shows an abounded dwelling fire at Wayne Road and Glover Street. At left are Daniels and Richard Story, of the Mutual Aid Fire Squad of Michigan, Inc. This house was set afire several times.

Wayne firefighters are seen here at Taft School for Fire Prevention Week. From left are Rick Goodlow, Joe Kadlec, John Ciuffetelli, and Lt. McGill

76

Sgt. Fred Arthur and Lt. Terry Turner are at Vanderburgh School on Stellwagon Street for Fire Prevention Week.

This photo shows a Gloria Street dwelling fire in the winter of 1981.

Wayne firefighters battle a fire in a dumpster after the carnival in the downtown area.

There was a fire at the Chevy showroom on Michigan Avenue, on July 2, 1983. Firefighters are working a hose in back of the cars. Aid came from Westland Fire Department, Canton Fire Department, and the Mutual Aid Fire Squad of Michigan, Inc.

A Wayne Fire Department ladder truck responded to this barn fire in Superior Township. This was really a training drill including Wayne Fire Department, Superior Township Fire Department, Dexter Fire Department, Ann Arbor Township Fire Department, Northfield Township Fire Department, and Salem Township Fire Department.

Wayne firefighters fight a fire in the old Carpenter Dodge Showroom on Michigan Avenue, March 9, 1984. Sgt. O'Brien is on the roof, Tom Molitor is on the ladder, Art Palo is at the base of the ladder, and Lee Gibelyou is at right.

Wayne firefighters were assisted by Westland firefighters at the oil storage tanks on Wayne Road at Forest Street. The August 27, 1984 fire began as a grass fire which a child started while playing with matches. Lt. George Ferguson is standing and firefighter Daniels is kneeling.

Fire Chief Ken Warfield (left) watches as firefighters battle a fire in one of the cottages at Nigeria Motel.

A Wayne firefighter battles a dwelling fire on Currier Street.

Lt. George Ferguson and Lee Gibelyou battle a dwelling fire on Currier Street. Flames were showing on arrival of the fire department. The fire was caused by arson.

This December 6, 1987 fire occurred in an apartment at Winifred Apartment, on Winifred Street just south of Michigan Avenue. Firefighter Joe Kadlec works a hose line.

Western Wayne County Fire Mutual Aid Hazardous Material team held a mock drill on October 11, 1988. Wayne firefighter Joe Kadlec assists a team member with his suite.

A Wayne-Westland community school bus was struck by a train on the CSX railroad tracks at Van Born Road. This was a drill of the Western Wayne County Fire Mutual Aid Association Haz-Mat Team. Several fire departments assisted in the drill. Wayne firefighters were first to arrive and find many injured persons with chemicals leaking from the train car.

Both Wayne firefighters and Wayne residents collected funds for "No Child without a Christmas" in 1985. From left to right are the following: (back row) Bev Campbell, firefighter Elmer Daniels, Brad Herst, Roy Klay, Bob Benny, firefighter Neil Prieskorn, and firefighter Joe Kadlec; (front row) Mike O'Brien, Larry Gresehover, John Ciuffetelli, and Fred Gill.

Wayne firefighters battle a fire in a 110-year-old house on Wayne Road at Earl Street in 1989. Sgt. Lee Gibelyou and Richard Story, of the Mutual Aid Fire Squad of Michigan, Inc., are pictured here with the hose line.

Fire Marshal Neil Prieskorn gets a ride home on his last day of work, June 30, 1983.

Brad Herst watches as firefighters battle a car fire. The car ran into a home at Second Street and Elm Street January 1, 1988.

On March 30 1989, Wayne firefighters attacked a working car fire in the parking lot of the Emergency Room at Annapolis Hospital.

On August 16, 1990, Wayne Fire Department responded to a report of a dwelling fire on Mildred Street. Firefighters arrived to find flames shooting from the second floor. The fire was caused by an overheated fan.

On July 16, 1990, Wayne firefighters responded to Westchester Towers on Michigan Avenue on a report of a fire on the 8th floor. Firefighters arrived to find flames showing from the window on the north side of the 8th floor. Westland Fire Department was called to assist at the fire, which was caused by a little girl playing with matches.

Would you purchase a used car from this group, training with the Jaws of Life in the rear of the fire station? Pictured from left are the following: (back row) Duane Reeves, Lt. Fred Gill, and Sgt. Rob Dahlman; (front row) Richard Berger and Ken Chapman.

Firefighter Russ Utt is pictured in training.

Lt. George Ferguson reloads hose after a dwelling fire on Winslow Street in 1990.

At a rollover car accident on Michigan Avenue East, east of Howe Road, firefighters give aid to the driver of one car.

Firefighters Reynolds and Hines move one of the injured persons from the car.

This 1991 photo shows firefighters Mike McKee, Tim Reynolds, Scott Knepshield, Duane Reeves, Sgt. Rick Waldrop, and Lt. Daniels.

Firefighters Larry Gresehover, Jim McCully, Rob Dahlman, Ken Hines, and Lee Gibelyou appear with the department's three rescues. The rescue at the right is new.

Firefighter Bill Thomas attacks a fire at Hickory Hollow in the second floor of a townhouse.

Firefighter Richard Berger and Captain Joe Kadlec are seen at Operation Prom Night at Wayne Memorial High School.

90

During Operation Prom Night at Wayne Memorial High School, firefighters and police officers staged a mock traffic accident involving alcohol. Firefighters remove one of the mock injured students.

Captain Lee Gibelyou and other firemen remove one of the mock bodies to a waiting police officer Williams with a body bag. The mock accident was staged for the Senior Class of WMHS before the Senior Prom.

A dwelling fire occurred at 5158 Niagara Street on June 23, 1991. In this photo, captain Gibeloyu and a firefighter enter the dwelling with a hose line.

This is the dwelling fire on Nyman Street. At left is retired Lt. George Ferguson, to his right are firefighter Russ Utt and Fire Chief Wayne Bennett.

Fire in a storage building at the Travel Log Motel on Michigan Avenue June 24 1994, Left is Captain Joe Kadlec and Right is Fiore Marshal Rob Dahlman.

Captain Gibelyou checks the interior of a dwelling fire on Hayes Street Condition Yellow "Smoke Showing" on arrival.

On February 24, 1996, as Engine 201 was moving from a car accident at Michigan West and Elizabeth to a dwelling fire on Hubbard Street, the rear wheels fell off the engine as it slowed to make the turn at East Michigan and Elizabeth. The 1985 Emergency One Engine was repaired and placed back into service.

Captain Daniels points to firefighter Richard Burger. The two firefighters were in the engine when the rear wheels fell off.

Firefighters train on the operation of the pumper in the State Wayne Theater parking lot. From left are Ciuffeltelli, Ken Hines, Mike McKee, Captain Lee Gibelyou, and Dave Wylie.

Lt. John Ciuffeltelli is pictured at the controls of Ladder-202.

Captain Rick Waldrop attacks a car fire at Brush Street and Third Street. The car was being pulled by a tow truck when it caught fire.

In this photo, Wayne firefighters and police officers are in a tug of war, and Fire Marshal Rob Dahlman falls in the mud.

Firefighter Hines looks up in this photo taken at a car accident on Wayne Road, just south of the Railroad.

Captain Reynolds Incident Commander at a working dwelling fire on Main Street, just east of Williams Street.

Captain Lee Gibelyou gets his last ride home on his retirement day, August 7, 1997.

This was Captain Lee Gibelyou's retirement breakfast at Leon's Restaurant. In the back row, retired Garden City firefighter Terry O'Callaghan talks with Shirley Gibelyou and Lee. To Lee's right is Brad Herst. Sitting is retired Lt. George Ferguson, retired Fire Chief Ken Warfield, and retired Fire Chief Hank Goudy, who hired Lee. Former Lt. Fred Gill has his back turned.

Firefighters respond to a working townhouse fire on the second floor in Hickory Hollow.

Retired Lt. Owen McGill (in shorts) helps pick up hose at a garage fire on Ash Street in 1997.

Captain Gibelyou, firefighter Mike McKee, and Lt. Tim Reynolds assist a man with a broken leg at Wayne and Annapolis in a traffic accident.

Firefighter Ken Chapman is assisted by Sean Bell with a new air bottle for his SCBA at a factory fire on Clinton Street.

Firefighter Ken Hines (sitting) and firefighter Mike McKee are pictured in the parking lot of the Wayne State Theater, in training.

Firefighters attack a working house fire on Third Street. Mutual Aid was received from Westland Fire Department. The fire was caused by an overheated fish tank.

Off-duty Hazel Park firefighter Rich L. Story II assists Lt. John Ciuffeltelli with changing his SCBA bottle at the dwelling fire on Third Street, which started due to an overheated fish tank.

Wayne firefighters take a break at a dwelling fire on Third Street. Firefighter Ken Chapman is facing the camera, the man in the back wearing a plaid shirt is Wayne Fire Chief Mike O'Brien, and behind him are Westland firefighters.

Lt. Larry Gresehover, Incident Commander of the dwelling fire on Third Street, watches as firefighters ladder the dwelling.

Firefighter Lee Gibelyou attacks a dumpster fire at Wayne Memorial High School.

103

In this March 1999 photo, Lt. Larry Greashover approaches a Condition Red dwelling fire on Fletcher Street. The fire destroyed the house.

Wayne Police K-9 Officer Foley (on sidewalk) watches as Wayne firefighters enter the dwelling fire. The man on the left is Fire Chief Mike O'Brien.

Fire Marshal Larry Gresehover (left) and firefighter Dave Wylie (in shirt), and Fire Chief Rob Dahlman watch as firefighters mop up at a garage fire on Currier Street. The fire also destroyed a vintage Ford Thunderbird.

This was a garage fire on Currier Street. Firefighter Dave Wylie and Engineer Andy Stager are in the foreground, Captain Tim Reynolds and the property owner are in the background.

Wayne firefighters, Wayne police officers, and St. Joseph Hospital flight crew pose after landing zone training in the City Park on Forest Street.

Wayne firefighters attack a fire in a tow truck in the parking lot of Westchester Towers on Michigan Avenue. The truck was driving along Michigan Avenue when it caught fire.

Lt. Terry Turner (far left) and firefighters overhaul a garage fire on Richard Street. The fire caused power lines to fall on fences in the area and charge several yards until power was shut off.

Wayne Fire Department was called to Parklane Hotel on Michigan Avenue for a car fire. In this photo, Captain Joe Kadlec attacks the fire.

Firefighters Elmer Daniels and Tim Reynolds give oxygen to a cat rescued from a basement fire on Ash Street. The cat survived.

A Rescue-203 2002 Freightliner AEV, the Wayne Fire Deparment's newest truck.

Wayne firefighters use Ladder Truck-202 to place Santa on the roof of the State Wayne Theater in 1993 after the Christmas Parade.

Firefighter Rob Dahlman receives assistance with his SCBA from firefighter Rick Waldrop at a dwelling fire on Annapolis Avenue.

Wayne Ladder Truck-202 responded to Inkster on a working warehouse fire on Inkster Road, in a snowstorm. Dearborn Heights Fire Department also assisted at this fire.

Firefighter Ken Hines is pictured during a hose drill in the parking lot of the State Wayne Theater.

Wayne firefighters were called to this Condition Yellow "smoke showing" pile of junk in the Wayne County Roads yard on Howe Road. The junk was picked up along the freeways. Captain Mel Moore is standing on the ground next to the engine, and firefighter Andy Stager is on the rear of the fire truck. Ford Motor Company brought extra foam to the fire.

Firefighter Bob Thomas attacks the fire at the Wayne County Yard with a hand line.

On April 11, 2002, Wayne Fire Department held an open house for all firefighters at the old Fire Station on Wayne Road before it was torn down. Pictured from left to right are the following: Retired Captain Joe Kadlec, Retired Fire Chief Mike O'Brien, Retired Lt. Owen McGill, Retired Fire Chief Wayne Bennett, Retired Sgt. Fred Arthur, Fire Chief Rob Dahlman, Retired Fire Chief Ken Warfield, Retired Westland Fire Chief Ted Scott, and Captain Tim Reynolds; (front row) Lt. Richard Berger, firefighter Cindy Boring, firefighter Brian Meszaros, firefighter Sean Bell, Captain Scott Knepshield, and firefighter Mike McKee.

Retired Lieutenants George Ferguson (right) and Terry Turner (left) are pictured next to Engine-211 at the old station.

A truck struck a power line at Brush Street and Washington Street, knocking the line down, which caused a gas main to catch fire. Wayne Fire Chief Rob Dahlman talks with Assistant City Manager Bob English (left) and City Manager John Zech (right) as firefighters, DPW, and gas company staff work in the background.

On September 11, 2002, a memorial service was held in Charles Goudy Park in honor of September 11, 2001. At left, Captain Mel Moore rings the bell in honor of the 343 firefighters killed in the attack. City of Wayne Mayor Abdul "Al" Haidous is at the podium.

Members of the Wayne Fire Department and the Wayne Police Department are pictured after memorial services. Not all members are present.

Wayne firefighters and Westland firefighters competed in "water ball" at the Wayne sidewalk sale. The battle took place on Park Street just east of Washington.

This is the 1962 Ford C-800 American La France 1,000-gallon-per-minute pumper with a 500-gallon water tank. The rig cost $42,000 and served until 1984.

The Temporary Fire Station is on the north side of Forest just east of Biddle. When the fire department moved into the new Wayne Road Station, this building became the DPW building.

Wayne Fire Department's fifth fire truck was a 1975 Mack-CF pumper. This rig had a 1,500-gallon-per-minute Hale pump, a 500-gallon water tank, two 20-gallon foam tanks, and a 50-foot ladder. The new rig cost $110,000 and remained in WFD until 1997. This was the first lime yellow-colored fire truck.

Four
MICHIGAN AVENUE FIRE

In the opinion of the author, the April 13, 1985, Michigan Avenue Fire was the largest fire in the history of the Wayne Fire Department.

At 1259 hours, April 13, 1985, Wayne Fire Department responded to Alarm 1985-368. The Schafer Building, a two-story building built in 1927, was three blocks from the fire station at 35164 Michigan Avenue West.

Wayne firefighters arrived to find heavy smoke showing from Carousel Beauty Shop. They entered the building to find heavy fire in the ceiling. The following stores in the Schafer Building also had fire in them: Nationwide Income Tax, Exotic Ports, Pat Flight's Keyboard World, and Dennis Wayne, Inc.

Lt. Terry Turner was the Incident Commander and requested all off-duty firefighters to be recalled and requested Mutual Aid from Westland Fire Department. The first arriving off-duty Wayne firefighters were required to respond to a second fire for an arson fire in a dwelling.

Deputy Director of Public Safety Fire Division Ken Warfield arrived at the Michigan Avenue location and requested Mutual Aid from the City of Romulus Fire Department, the City of Inkster Fire Department, and Canton Township Fire Department. The Schafer Building fire was arson and caused $1 million in losses; 47 firefighters used one million gallons of water to extinguish the fire, pumping water through 7,000 feet of fire hose and using seven fire apparatus to pump water.

Two persons were arrested for setting the fire. One served jail time the other was placed on probation; the fire destroyed six businesses in the half-block long Schafer Building.

Firefighter Richard Berger mans a hand line as firefighter Rick Waldrop operates the ladder on Engine-201 at the Michigan Avenue Fire.

The crew of Engine-1401 of the Westland Fire Department uses a hand line on the rear of the building, the north side of the fire. Westland, Inkster, and Romulus Fire Departments assisted Wayne Fire Department at this fire.

On the left are Wayne firefighters Dahlman and Berger with a hand line, the crew of Engine-601 of the Inkster Fire Department is on the right.

The name says Daniels, but this is really Corrigan of the Westland Fire Department using Daniels' coat, and manning a deluge gun on the southwest side of the building.

Wayne firefighters Rob Dahlman and Richard Berger are pictured on the south side of the building.

This photo shows the south side of the building looking northwest. Wayne firefighters, Inkster firefighters, and Romulus firefighters are pictured. Standing to the right is Lt. Turner, who was Incident Commander.

This photo looks northeast. At this time, firefighters were moved back in case the wall fell.

This photo was taken the morning after the fire, approximately 9:45 a.m.

At 5 a.m., Lt. Geroge Ferguson, Sgt. Fred Arthur, and Lt. Terry Turner take a break in the barber shop next door directly west of the fire.

Lt. George Ferguson takes a rest on the second floor fire escape around 7:45 a.m. the morning after the fire.

Five
FIRE CHIEFS

During its 93 years of service to the community, the Wayne Fire Department has had only seven men serve in the position of Fire Chief. This is a small number compared to the years of service.

The low number of fire chiefs is because Charles Goudy, the first fire chief, served in the position for 27 years, and Hank Goudy served in the fire chief position for 34 years. That makes a total of 59 years of service between just two fire chiefs.

Charles Goudy became the first fire chief in 1911. Goudy was also the Superintendent of the Department of Public Works and oversaw the 1914 installation of the water main system, including fire hydrants. Chief Charles Goudy was also a Village Marshal and Highway Commissioner. He became the full-time Fire Chief in 1928 when a full-time fire department was started. Chief Goudy passed away October 7, 1938, at the age of 64; he had serviced the Wayne Fire Department for 27 years.

Fire Chief Hank Goudy, Charles Goudy's son became a member of the Wayne Volunteer Fire Department as a teenager, and in 1928 was one of the three men hired as a full-time firefighter. Hank Goudy served as the President of the Great Lakes Fire Chief Association for a couple of terms, and helped to start the Western Wayne County Fire Mutual Aid Association. Hank retired on June 30, 1972, after serving the Wayne Fire Department for 44 years. He was the longest serving fire chief, a position he held for 34 years. Upon Chief Hank Goudy's retirement, he became the Director of the Wayne Historical Museum. Hank Goudy passed away on September 30, 2000.

Fire Chief Russ Johnson became Acting Fire Chief of the Wayne Fire Department on March 3, 1972, and then became Fire Chief on March 29, 1972. Russ became the third fire chief of the Wayne Fire Department. Russ suffered a heart attack on August 13, 1974, at a major fire at Northside Hardware. This attack caused Russ to retire from the Wayne Fire Department at age 47, after 24 years of service to the Wayne Fire Department. Russ is credited with modernizing the Wayne Fire Department. On September 26, 2002, Russ passed away in his home in Florida.

Ken Warfield became the fourth fire chief of Wayne Fire Department. Warfield was appointed fire chief in May of 1975 from the position of Assistant Fire Chief/Fire Marshall. As a firefighter he started the IAFF Local-1620 of the Wayne Fire Department. As a fire chief, Warfield upgraded the fire department's equipment and training. Warfield became the only fire chief under the Department of Public Safety, and his title was changed to Deputy Director Fire Division. He was also a certified police officer. Warfield received serious burns in a 1971 dwelling fire on Annapolis Avenue. Ken retired on December 1, 1989, and went on to become the Mayor of the City of Wayne.

Wayne Bennett became the fifth fire chief of the Wayne Fire Department. Chief Bennett attempted to get a new fire station built and add additional firefighters to Wayne Fire Department. His attempts were not successful. Bennett spent $200,000 to rebuild Ladder-202 the 1978 Sutphen Tower and changed the white reflecting striping on the lime yellow rigs to blue. Fire Chief Wayne Bennett retired on December 31, 1993, after 31 years of service.

Fire Chief Mike O'Brien is pictured on the right of the photo, at a working dwelling fire on Fletcher Street. O'Brien became the sixth fire chief of Wayne Fire Department on January 1, 1994. Chief O'Brien was fire chief when a debate over a new fire station took place. O'Brien retired on December 31, 1999, after 30 years of service.

Fire Chief Rob Dalhman became the seventh chief of the Wayne Fire Department in January of 2000. Chief Dalhman was in office when a temporary fire station was built and firefighters worked out of this building for almost 2 years and saw the move into the new fire station at 3300 Wayne Road. Dalhman served when the Advanced Life Support was started, and worked to replace aging fire apparatus, along with adding firefighters to the department.

Different fire chiefs are pictured here. They include Rob Dalhman, Retired Fire Chief Mike O'Brien, Retired Fire Chief Wayne Bennett, Retired Fire Chief Ken Warfield, and Retired Westland Fire Chief Ted Scott. Scott joined the Wayne-Nankin Fire Department and moved on to the Nankin Township Fire Department, later climbing the ladder to become Westland Fire Chief.

This photo shows the groundbreaking for the new Wayne Fire Station at 3300 Wayne Road. The old station is still standing in the background. Firefighters, both active and retired, city officials, and residents took part in this groundbreaking on June 1, 2002.

This is the new Wayne Fire Station at 3300 Wayne Road, pictured in December of 2003.